Basic
Figure
Drawing
TECHNIQUES

edited by
GREG ALBERT

NORTH LIGHT BOOKS
CINCINNATI, OHIO

Basic Figure Drawing Techniques. Copyright © 1994 by North Light Books. Printed and bound in the United States of America. All rights reserved. No part of this book may be reproduced in any form or by any electronic or mechanical means including information storage and retrieval systems without permission in writing from the publisher, except by a reviewer, who may quote brief passages in a review. Published by North Light Books, an imprint of F&W Publications, Inc., 1507 Dana Avenue, Cincinnati, Ohio 45207. 1-800-289-0963. First edition.

98 97 96 95 94 5 4 3 2

Library of Congress Cataloging in Publication Data

Basic figure drawing techniques / edited by Greg Albert. — 1st ed.
 p. cm. — (North Light basic painting series)
 Includes index.
 ISBN 0-89134-551-5
 1. Figure drawing — Techniques. I. Albert, Greg II. Series.
NC765.B28 1994
743'.4 — dc20 93-30507
 CIP

Edited by Greg Albert
Interior design by Sandy Conopeotis
Cover design by Paul Neff

Artwork and text originally appeared in previously published North Light Books. The initial page numbers given refer to pages in the original work; page numbers in parentheses refer to pages in this book.

Albert Greg. *Drawing: You Can Do It!* © 1992 by Greg Albert. Pages 4-6; 44-45; 52-53; 62-63; 58-59; 74-77; 67; 80-81 (2-3; 9; 10-11; 12-13; 14-15; 16-19; 20-21).
Brown, Marbury Hill. *Bodyworks: A Visual Guide to Drawing the Figure* © 1990 by Marbury Hill Brown. Pages 1; 26-28; 31; 33; 36-37; 40-41; 47; 46; 48-49; 52-53. (70; 71-73; 74; 75; 76-77; 78-79; 80; 81; 82-83; 84-85).
Dodson, Bert. *Keys to Drawing* © 1985 by Bert Dodson. Pages 63-67; 16; 70-85. (4-8; 22-37).
Reed, Walt. *The Figure* © 1984 by Fletcher Art Services. Pages 12-13; 10-11; 38-39; 20-21; 23; 25; 24; 22; 28-37; 44-45; 75; 27; 76-79; 82-85; 98-99; 106-107; 66-67; 108-113. Artwork on page 113 by Albert Dorne. (38; 40-41; 48-49; 50-51; 52-53; 54; 55; 56; 57; 58-67; 68-69; 100; 101; 102-105; 106-109; 110-111; 112-113; 114-115; 116-121).
Sheppard, Joseph. *Realistic Figure Drawing* © 1991 by Joseph Sheppard. Pages 3-4; 5-10; 16-21; 32; 34; 22-27 (38-39; 42-47; 86-91; 92; 93; 94-99).

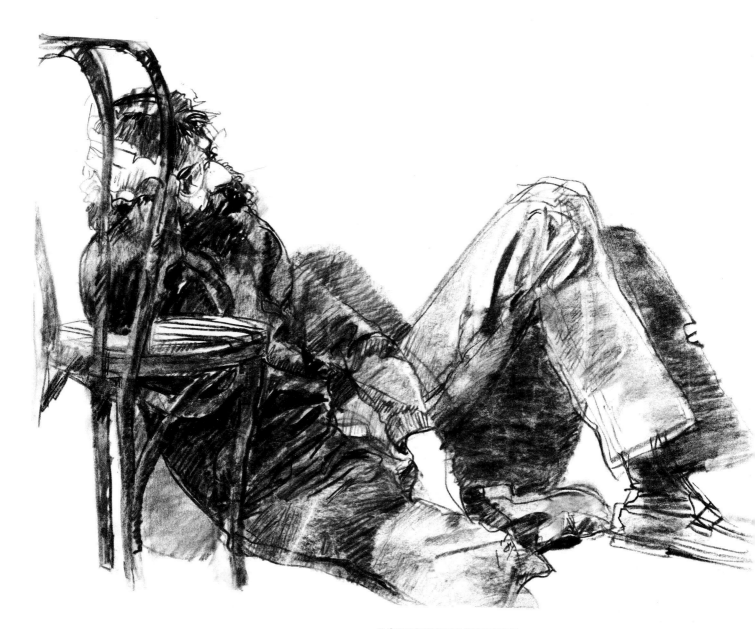

ACKNOWLEDGMENTS

The people who deserve special thanks, and without whom
this book would not have been possible, are the artists whose
work appears in these pages. They are:

Greg Albert

Marbury Hill Brown

Bert Dodson

Walt Reed

Joseph Sheppard

TABLE
of
CONTENTS

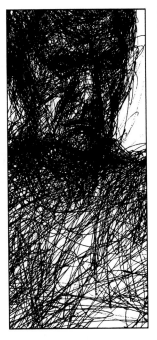

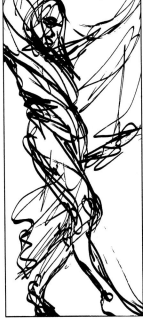

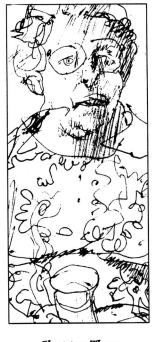

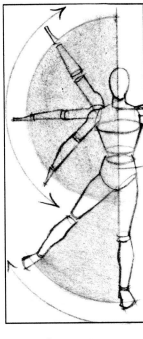

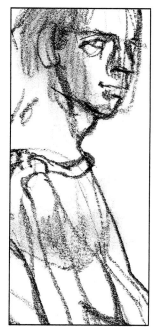

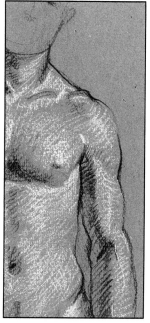

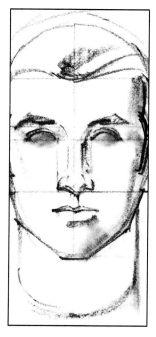

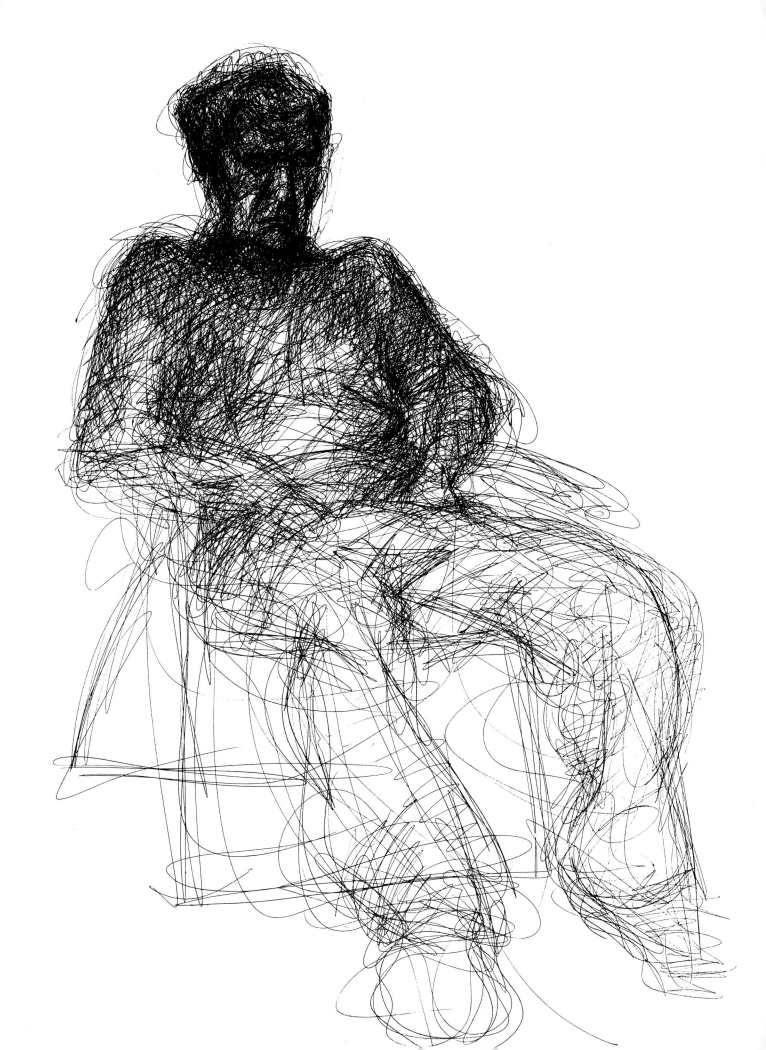

INTRODUCTION

The human figure is considered one of the most challenging and most satisfying subjects an artist can tackle. No other single subject offers as much opportunity for the artist to study grace, strength, and the power of emotion. And it's no more difficult to learn to capture the human form than it is to learn to capture other subjects. Of course, to draw the figure well, you will have to work at your craft, but we believe you can begin to see satisfying results from the start. Figure drawing is a learnable skill, and it can be easier than you think, especially if your earlier efforts were frustrating.

The key to successfully drawing the human form is to practice one concept at a time, as well as developing an understanding of the form and structure of the human body. This book will help you explore the human form and learn the rules that helped the "masters" produce figure drawings of unforgettable strength and beauty.

We have assembled this book from some of the best teaching available on figure drawing. In the first chapter you will find useful information on materials and basic techniques. The remaining chapters teach the basic principles of rendering the form on paper, capturing gesture, drawing from models, utilizing the rules of proportion, and drawing details, such as hands and facial features. The only additional ingredient you will need is practice and the knowledge that interest and effort overcome any lack of that elusive quality we call "talent."

Chapter One
GETTING STARTED

Drawing is not an expensive pursuit. All you really need is a pencil and some paper. Later, when you have a good sense of the principles of drawing and a clearer commitment to making a valid artistic statement, you can indulge yourself with a multitude of varied, specialized and more expensive drawing materials.

To begin with, assemble a basic set of materials as follows. If you buy these all at once, you won't have lack of materials as an excuse for not drawing. If cost is a serious consideration buy basic pencils, erasers and paper, and add to your materials as your studies progress. Keep your material neat and in one place.

Soft (6B or 4B) Graphite

A graphite stick is a 3-inch-long, 1/4-inch-square stick of "pencil lead." Buy the very softest you can find, at least 4B; 6B is best. Graphite sticks will be used for gesture scribble drawing when you need something that will glide smoothly over the paper. By the way, the higher the *B* number, the softer the lead; the higher the *H* number, the harder the lead.

Ebony Pencil

An Ebony pencil is a brand of pencil with a thick, soft lead. It makes a very nice black line, and is excellent for contour drawing when it has a good sharp point. An ordinary no. 2 pencil will work for practice drawing, but a pencil with a soft lead is best. Hard-leaded pencils scratch the paper in an annoying way.

Drawing Board

You will need a 20″×26″ drawing board that is flat, smooth and stiff, and won't give your drawings an unwanted texture. A piece of ¼-inch tempered Masonite that has rounded corners

works well. It's lightweight, inexpensive, and thin enough that you can use large clips to hold your paper in place. Go to a lumber or building supply house and ask them to cut a sheet of Masonite to size. You can cover the working surface of plywood with smooth cardstock, such as railroad board, or you can use a portable drafting board, but both are heavy and cumbersome. They are also thick, making it difficult or impossible to use clips to hold the paper.

Pad of 18″ × 24″ Newsprint

Newsprint was once identical to the paper newspapers were printed on, and was an inexpensive paper for drawing. It's no longer so inexpensive, but it's still the best surface for many of the exercises in this book. Newsprint has a soft, grainy texture and a creamy color. Because it's made from wood pulp, it's impermanent. Drawings on newsprint will yellow and become brittle in just three or four years. The paper's deterioration is hastened by exposure to sunlight. This is not a paper suitable for drawings you want to keep, but it is suitable for practicing. Either smooth or rough newsprint can be used.

18″ × 24″ White Drawing Paper or Cartridge Paper

This is the closest thing to "generic" drawing paper you'll find. It is a grainy, white paper with a slight tooth (grain or texture) that holds chalk and Char-Kole well. It is sometimes called "cartridge" paper, because it was originally used to wrap the ball and powder charge for muskets in the nineteenth century.

18″ × 24″ Graph Charcoal Paper

Charcoal paper is specifically manufactured for use with soft, powdery ma-

terial such as charcoal and pastel. It has a distinctly patterned grain or texture that catches and holds the powder. This paper comes in many colors, but try a medium gray for exercises in this book (although dark or light gray will work fine). The very best charcoal paper can also be very expensive. Buy the cheapest kind you can find.

Four Large Clips

Use large, metal, spring clamps to easily and quickly secure the edges of your paper to the drawing board. One for

each corner is best. Any large clip or fastener, such as a no. 4 Boston or Bulldog clip or a no. 100 Binder Clip, will work. Don't place a loose sheet on your board and hold it there with your free hand or elbow.

Char-Kole

Char-Kole is a soft, black chalk made by Weber Costello. It is powdery and fine grained, making a rich, velvety black that is easy to blend with a fingertip or tissue. It also can be manipulated or removed readily with the erasers we'll discuss on these pages. No other material can duplicate the qualities of Char-Kole, however, soft-compressed charcoal will work adequately.

Soft, White, Blackboard Chalk

White chalk and Char-Kole can be blended on paper to make a wide range of grays. Buy a box of children's ordinary blackboard chalk at your local discount or variety store. Avoid any hard or "dustless" chalks.

Plastic Eraser

An eraser is not merely a device for making corrections. It can be used for creating many effects on paper. When you do need to make a correction, use a white plastic eraser, such as those made by Factis or Mars. These erasers have remarkable abilities to move or remove graphite or charcoal from paper—often you can restore the paper's surface to nearly its original whiteness. A soft, pink eraser, such as a Pink Pearl, will also work nearly as well.

Kneaded Eraser

A kneaded eraser is a good complement for either the plastic eraser or the Pink Pearl. A kneaded eraser must be pulled and worked like taffy before it can be used. The warmth of your hands and the stretching and kneading activate its ability to absorb loose powder from a drawing. The kneaded eraser should be rolled over the paper first, so it can pick up the most loose powder. Rubbing with the kneaded eraser can create little bits of eraser "noodles" and can grind the powder into the paper.

Bottle of Black India Drawing Ink or Black Writing Fluid

Cotton-Tipped Swabs

One Large, Black Crayon or a Soft, Black, Lithography Crayon

Use black or a favorite color just for variety.

Cheap Cardboard Portfolio

Buy a large (approximately 30″ × 24″) cardboard portfolio in which to store your practice drawings. You will probably not want to keep all of them. Save and date a few just for a record and as a way to check your progress.

Spray Fixative

Spray the drawings done with charcoal, chalk or other powdery materials with a fixative. Read and follow the directions on the can. Spray lightly. Several coats are better than one heavy one.

A Box for Supplies

A fisherman's tackle box or mechanic's toolbox is a handy way to keep all of your drawing tools together. Some fancy boxes with many small compartments are made just for artists.

Apron or Smock

Drawing can sometimes be a dirty job. Wear old clothes or buy a cheap apron or smock to protect yourself.

Notes on Media

For the sake of organization, we've divided drawing media into two rough categories, *ink* and *powder*. A complete discussion of the different uses and properties of each medium when used on different surfaces would fill a large volume. For that kind of detail, read *The Artist's Handbook*, by Ralph Mayer. For most of us, however, a more general exploration will suffice. Try the following experiments in different media and then compare your results. Keep the subject the same — a little fragment or a copied photograph is enough — and keep it simple. Compare not only the end results but also how each of the different media felt in your hand.

Ink Materials

This group includes brushes and pens and felt-tip markers of all kinds. You will find their lines fluid, graceful and sharp. Tips and points range from very broad to very fine and deliver crisp, black lines. To establish tone, ink washes or hatching is employed.

Pen and ink (crow quill point). Good line variety, thickness varies with pressure. Good for fine textures, sharp details.

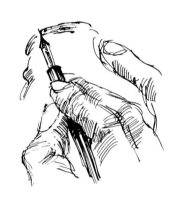

Pen and ink (cartridge fountain pen). The continuous feed of ink is very handy. Rounded tip (bowl point) allows for smooth changes in direction. Portable.

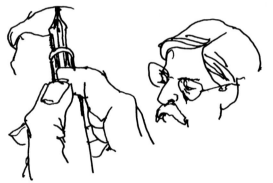

Felt-tip marker (water soluble). Like the permanent marker, but produces weaker blacks. Capable of instant tonal effects if you rub with a wet finger.

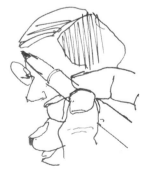

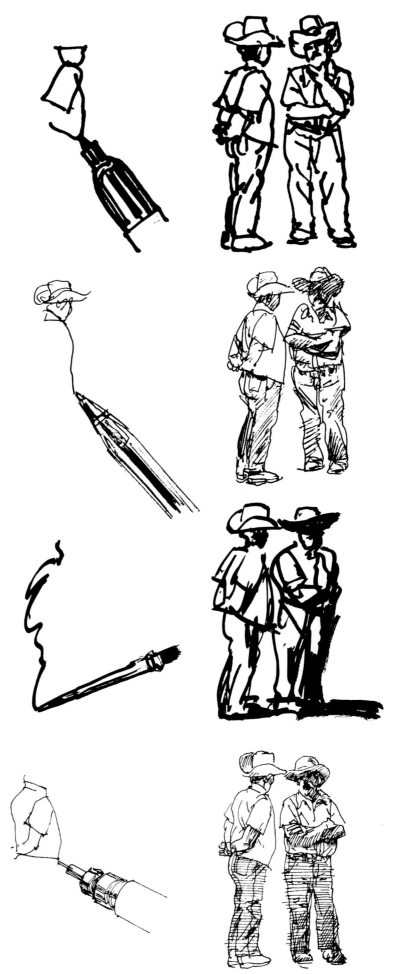

Felt-tip marker (permanent). Bold, decisive look. Nice solid blacks. Can vary line thickness by shifting from point to side.

Ballpoint pen. Extremely versatile. Produces both dark and light lines, depending on pressure used. Doesn't smear. Portable.

Brush and ink. Very free. Good for explosive, unpredictable effects. Large, solid blacks obtained quickly. Interesting dry-brush effects on rough paper. Mixes easily with water for gray tones.

Mechanical pen (fine point). Even line weight, continuous feed. Good for long, connected lines and crosshatching. Excellent for very small drawings.

Powder or Dry Material

This group includes pencil (graphite), charcoal (vine and compressed), crayon (usually Conté) and chalk. Generally, these materials are dry, tonal, malleable, fragile and conducive to bold, sweeping strokes. All are available in either stick or pencil form. Charcoal, crayon and chalk in stick form are good for working large. They deliver an explosive black line or a broadside tone. In stick form they're messy and fun. There are no gold stars for clean fingernails.

Pencil is hard to classify because you can do almost anything with it. The piano of drawing instruments, it will help you compose, think and sketch, and can be used for finely finished pieces.

Pencil. The most versatile tool, equally adaptable to sharp lines, soft tone, and all ranges in between. Available in leads from soft (B series) to hard (H series). Cheap, convenient and portable.

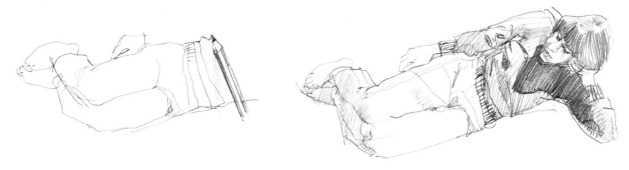

Vine charcoal. Very soft effects, rather gray, highly malleable, subtle, fugitive.

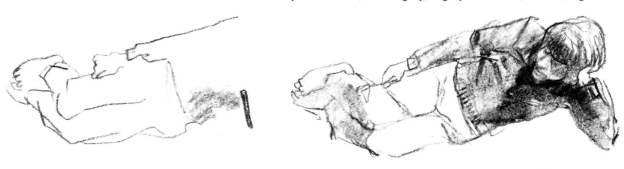

Compressed charcoal. Strong blacks, bold lines, good for working large. Edges blur nicely.

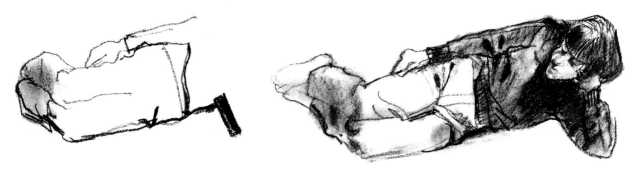

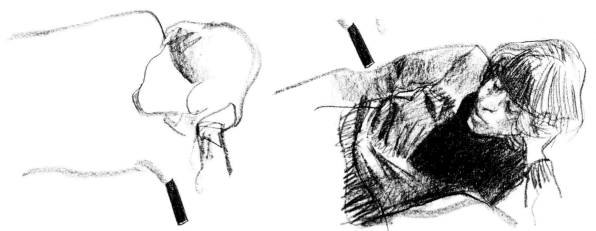

Conté crayon. Good variety of effects from use of both side edge and point. Shows tooth of paper well. Good for building tones gradually.

Rubbing Procedures

An excellent feature of the powder materials is their malleability. Smearing, smudging, wiping over and blurring can yield remarkable effects instantly.

Using thumb or fingers . . . to soften an edge . . . or tie two shapes together.

Using a paper stump . . . to soften fine details . . . or to draw with.

Using a hand or tissue . . . to lighten a tone . . . or to soften.

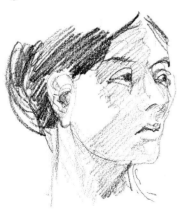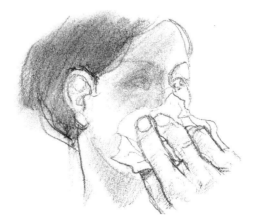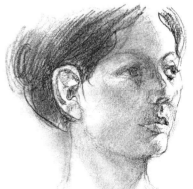

Erasing as a Drawing Method

Let's explore using the eraser as a drawing tool.

Knocking back. When an area is a confused tangle . . . reduce it without fully erasing it . . . and your restatement will have less competition.

Picking out lights. Establish a tonal area . . . pinch the kneaded eraser into a point or a sharp edge . . . and pick out the highlights.

Using a mask. When sharp edges are needed . . . cut out the desired highlight shape from a piece of scrap paper . . . and erase through the window.

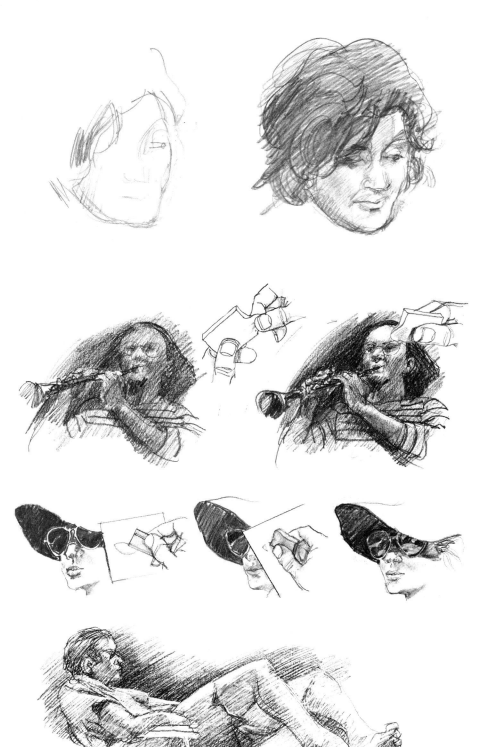

Erasing with razor blade. Light scraping will reduce the tone. Sharp details can be scraped out, especially in Conté. This technique works for ink as well.

Chapter Two
GESTURE

One of the best warm-up exercises for figure drawing is called *gesture drawing*. It is an excellent way to become confident with the figure, and it encourages you to loosen up and work spontaneously.

Gesture drawing is often called scribble drawing. It's almost as easy as scribbling, but there are a few simple and important differences that make gesture drawing one of the best ways to improve your figure drawing.

First, gesture should never lose the loose, almost unrestrained quality of scribbling.

Second, when you do a gesture drawing, you are not only making a loose, scribbly sketch of what the subject looks like, you are also trying to tell more about what your subject is and what it is doing. You are not drawing only what you see, but what you feel is the essential character or action of your subject. It is often hard to describe gesture drawing without resorting to almost mystical terms, because gesture drawing records your impressions, thoughts and feelings about your subject. Gesture is a spontaneous record of what you think best captures the inner vitality of your subject. Draw what your subject is like or what it is doing.

Sometimes gesture drawings are called action drawings. "Action" makes sense when you're drawing the figure. It's pretty obvious what action

the figure is doing, even if the figure is motionless—she or he is standing or sitting, bending, reaching or twisting.

Gesture drawings should only take about a minute or two to complete. You shouldn't work at gesture drawings. Instead, you let them happen. You put the pencil to paper and begin to draw loosely and spontaneously with an uninterrupted movement of the hand and shoulder. Keep your drawing instrument moving, neither stopping it nor lifting it from the paper.

Whatever your subject, make it fit the paper so no part is left off. This is one of the most important parts of gesture drawing. If you need to make a mark on the top of the paper for the topmost part of your subject and then make a mark on the bottom for the lowest part, do it. Get in the habit of "sizing" your drawing to fit the paper. If you start too large, just scribble your subject smaller right on the paper. Never start over—it's only a minute or so of drawing anyway.

If you consciously try to make whatever you draw fit on the paper, you'll get in the habit of seeing how the sizes of the various parts of your subject are related. You'll also develop an instinctive sense of proper proportion and composition. You will develop the habit of thinking about how whatever you are drawing fits whatever size and shape paper you use.

Rule 1: Scribble.

Rule 2: Draw what your subject is doing.

Rule 3: Don't pick up or stop the pencil.

Studying Gesture

For the next two exercises, you'll need a soft graphite stick and paper larger than ordinary typing paper—try newsprint or used computer paper.

By its very nature, gesture is ideally suited for drawing people. Your family and friends can be your first models, even if they are unaware of it! The best way to learn how to do gesture scribble drawings of people is to work with a cooperative model. This person can be a family member or friend. It could be an artist friend with whom you can trade posing sessions or a clothed or nude model who poses for a session with fellow artists.

It helps if you give your model, whomever it is, good instructions. Begin by asking him or her to assume poses based on everyday activities, such as sitting attentively on a chair, slouching on a chair, sitting facing over the chair back, standing in a subway or bus, leaning against a wall and so on. Each pose shouldn't last more than a minute to a minute and a half, never longer than two minutes.

Then request they "play statue" in a pose based on an ordinary activity such as swinging a bat, tennis racket or golf club, or sweeping, raking or chopping wood.

Once your model begins to literally "get into the swing of things" ask for more imaginative poses, all based on some specific action or activity. (This can be a lot of fun, by the way, and if you are alternating being artist and model for friends, posing will give you a lot of insight into what gesture is all about.)

Step 1.

Draw a few lines that account for the entire pose right away. You should know after five seconds of drawing if it will fit the paper. In the first seconds of the drawing you can expand or contract your scribble in order to accommodate the paper.

Step 2.

Keep the graphite stick moving, recording the action. You are picturing what the model is doing. Gesture is an image of action or implied action.

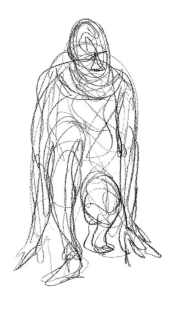

Step 4.
 Don't worry about what your drawing looks like. The goal is to practice identifying the gesture, distilling or extracting it so it can be presented on your paper.

Step 3.
 Don't stop or pick up the graphite: to do so would disrupt the unity of the drawing. Don't draw parts; draw the whole gesture.

D rawing gestures of people can be one of the most exciting and rewarding ways of drawing. The more you do, the more insight into the nature of "gesture" you gain. Since gesture drawings take only a minute or so to do, it's not too difficult to do hundreds before you know it. And you will need to do hundreds of gestures! Before that thought frightens you, if you did just five gesture studies each day — five minutes a day — you would have done one thousand drawings in about six months.

Gesture Variations

To keep from getting into unchallenged habits, vary your drawing procedure from time to time in small but significant ways. For instance, every once in a while switch hands and draw with your less-favored hand. This will feel awkward at first, but remember you're not drawing delicate details. Concentrate on the important points of gesture: Draw the action, draw the whole thing, don't stop or pick up the instrument, and keep the big picture in mind.

Try starting at the bottom of the paper and working up. This procedure is contrary to your normal habits of vision. You'll naturally be more mindful of fitting the whole image onto the paper. It's much more disturbing when you leave off the head of a figure than the feet.

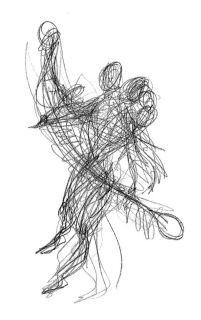

Moving Gesture

As in the previous exercise, ask your model to perform some repetitive action for about three minutes. For example, instruct the model to pretend he or she is picking up a box and placing it on a high shelf, or that he or she is chopping wood or swinging a golf club or a baseball bat. The model repeats the same action for the duration of the drawing.

Your subject matter is the action—the gesture—itself, not the body performing it. Make whatever marks you need on your paper to express the activity as it occurs in space and time.

There are no right or wrong ways to do this drawing. Five artists drawing the same action would invent five different ways to show motion.

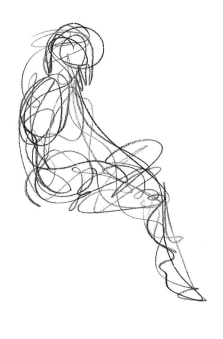

Flash Gesture

Ask your model to do a series of poses, one right after the other, changing every thirty seconds. Arrange your paper on your board so you can pull one sheet off quickly and work on the next. You'll only have enough time to establish the initial impression of the gesture, but it will still be a complete one. Ignore details and go for the grand view, the big picture.

After doing ten flash poses of thirty seconds each, ask your model to change every twenty-five seconds and do ten more. Then reduce the time to twenty seconds, then fifteen, and finally ten.

Gesture of Figure With Drapery

Ask your model to experiment with poses using a bedsheet. Encourage the model to wrap or drape the sheet around him or herself, or to hold it in various ways. Do a gesture of the way the fabric reacts to the body beneath it or to the pull of gravity. The way the folds fall and flow is the gesture of gravity made visible. This exercise is great training for drawing the folds of clothing.

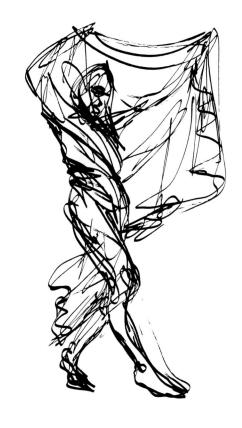

Memory Drawing

Instruct your model to assume a pose and to hold it for a full minute. The model can position him or herself so a clock or watch is visible (or he or she can count to one hundred silently). Do not draw. Instead study the pose carefully. Memorize the action, not the details. You can't retain what the model looks like as easily as you can remember the action or pose. Feel the pose with your own body. Imagine what that pose would feel like if your body held it.

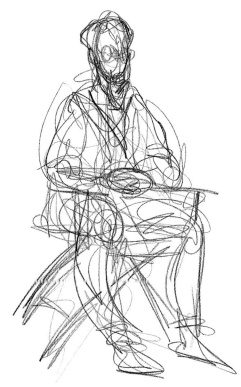

Use Ink and Cotton Swabs

Gesture drawing can be done with a lot of different materials. Drawing tools that make decisive marks rapidly are the best. In this project you're going to use cotton swabs dipped in black ink, a drawing tool that might sound unlikely at first. However, you will discover that an ink-filled cotton swab will make very bold, dark marks.

Other materials you'll need include a sheet of 18″ × 24″ newsprint or used computer paper, and a small cup to hold about a tablespoon of ink. (Money saving tip—for this kind of practice drawing, sheets of the daily newspaper *without* photos work well.)

These ink drawings will probably be quicker to do than those using the graphite stick because they get dark and more tangled faster, so try thirty to sixty seconds for each pose.

One way of drawing with the ink-saturated swab is to see if you can make a complete gesture with just one dip in the ink.

Step 1.
Draw the largest and most descriptive curves first.

Step 2.
Crystallize the energy with as few strokes as possible.

Step 3.
Finish with only the most telling details. Drawing with the ink and cotton swab is an exercise in economy.

> Cotton swab gesture drawings often have a powerful calligraphic quality. In fact, there is something in them reminiscent of Oriental brush painting. Variations include using pipe cleaners, cosmetic brushes, toothbrushes dipped in ink, as well as homemade pens fashioned from bamboo, twigs, sticks and feathers. In fact, almost anything you can dip into ink will render an interesting drawing.

Use the Side of the Charcoal

Gesture drawing is the product of three factors: the energy contained in the subject matter, the artist's personality, and the nature of the materials the artist is using. As you might have discovered with the ink and cotton swab gestures in the previous exercise, the materials you use are part of the gesture.

In this exercise, don't draw with the point of the graphite stick, but with the side of a flat, one-inch-long piece of a black or purple crayon or Char-Kole.

(The charcoal will make some dust, so be careful of the mess.) Again, you should use a large sheet of newsprint or scrap paper.

Use the side of the charcoal to make wide strokes.

Step 1.
Begin by making a long sideways stroke with the crayon or charcoal. Once again, account for the entire action embodied in the pose, from head to toe.

Step 2.
Continue to elaborate on the initial gestural impulse, using the side of the crayon. Since you can't use the point, you can't outline the shapes.

Step 3.
The wide strokes of your crayon will begin to fill up the volumetric shapes that are suggested. Stop before your drawing gets too solidly dark.

Use the side of the charcoal to make wide strokes.

Mummy Drawing

In these exercises we have been seeing three-dimensional form and drawing two-dimensional shape. We still want to create the impression of substance. Besides the visible appearance of an object, it is the weight and volume that make something tangible for us. We need to communicate the way things take up space and feel heavy or light. Our drawing must suggest substance in space by incorporating clues to the mass and placement of what we draw.

This exercise is a wraparound drawing of the human form. You'll need a stick of soft graphite and a sheet of 18″ × 24″ paper. Ask family or friends to pose for five or ten minutes, or draw a statue or figurine. Ask your model to sit or stand so you can see the entire pose. Begin with a gesture drawing. Now imagine that your graphite stick is a ball of yarn, and you're going to wrap the model completely in yarn. Start at the top and begin "wrapping." A mummy is an image that obviously comes to mind.

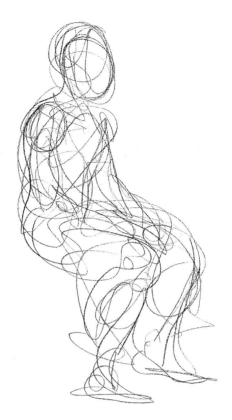

Step 1.
Begin with gesture drawing. Draw the whole figure; don't crop any feet or toes!

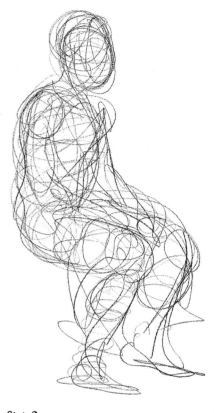

Step 2.
Begin "wrapping" the figure by encircling the forms as if the graphite line was a long strand of yarn or the binding around a mummy.

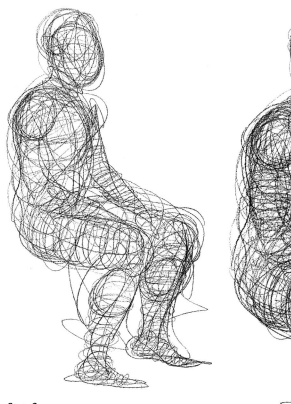

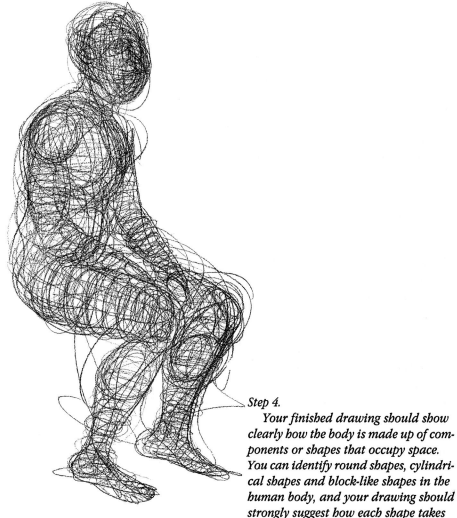

Step 3.
Continue wrapping the various forms of your model, defining the volumes as you go. Your drawing should begin to have a three-dimensional look.

Step 4.
Your finished drawing should show clearly how the body is made up of components or shapes that occupy space. You can identify round shapes, cylindrical shapes and block-like shapes in the human body, and your drawing should strongly suggest how each shape takes up a certain amount of space.

Doing mummy drawings of the figure will teach you much about how the figure is constructed, without the study of anything as complicated as artistic anatomy. The figure is composed of distinct forms that, once understood, can help you draw more convincing figures. A knowledge of how the figure is put together from smaller, geometric forms is a good basis for drawing the figure from memory, as in cartooning.

Weight and Mass Drawing I

This drawing will begin with some familiar concepts and add one more. In all, this drawing should take ten minutes. The first step is a gesture drawing, done with a soft, black litho crayon or using a fat, black crayon on a sheet of 18″ × 24″ white paper. This step will insure that your drawing has a lively energy, even when the gesture is obscured by subsequent drawing.

The second step is the same as in the previous exercise: Pretend you're wrapping the figure in yarn. It will give your drawing a sense of volume. In the last step you will fill those volumes up with imaginary "stuff." It helps if you consciously think of yourself as building up the drawing with a material like clay.

Keep scribbling in a gestural manner. Scribble more and darker where the object is heavier, more substantial, massive or bulkier. Imagine that you're a sculptor making a clay model, and the crayon is the "clay."

You need more clay where your subject is bigger, and less clay where your subject is smaller. Continue scribbling harder, darker and longer on your drawing where the object is heavier, and scribble less or lighter where it is less substantial. Pretend that you are adding clay to your model as you add more dark lines on your drawing.

Step 1.

Start with a gesture drawing. Make it large. Use the whole piece of paper.

Step 2.

Begin "wrapping" the figure just as you did in the previous projects. As you encircle the volumes of your subject, think about how the drawing expresses the way your subject takes up space.

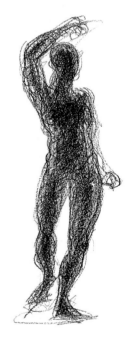

Step 3.

Keep scribbling in the same gestural manner. Scribble harder, darker and longer on your drawing where the object is heavier, and scribble less or lighter where it is less substantial.

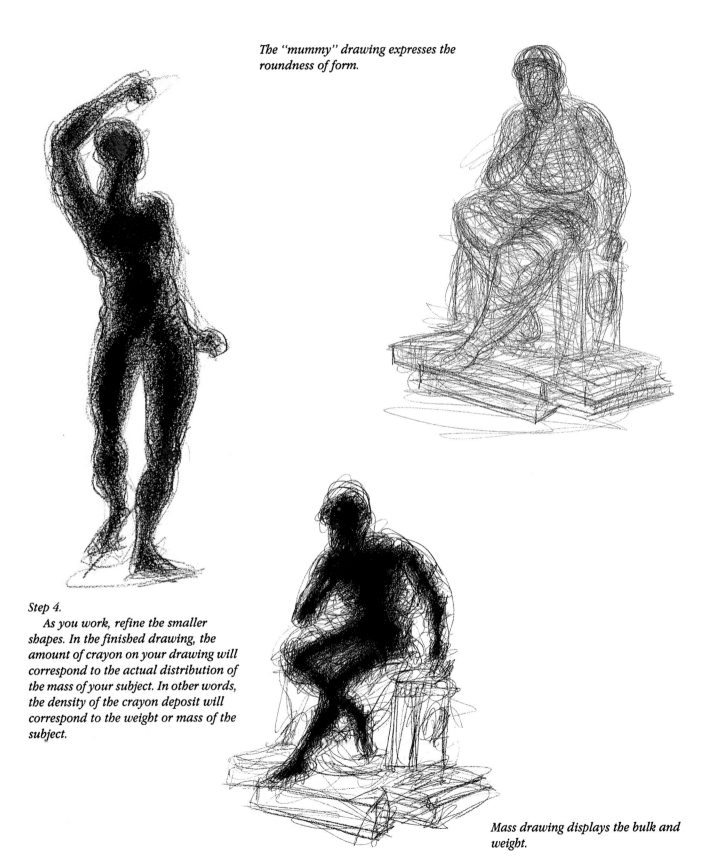

The "mummy" drawing expresses the roundness of form.

Step 4.

As you work, refine the smaller shapes. In the finished drawing, the amount of crayon on your drawing will correspond to the actual distribution of the mass of your subject. In other words, the density of the crayon deposit will correspond to the weight or mass of the subject.

Mass drawing displays the bulk and weight.

Weight and Mass Drawing II

Thinking about the figure in terms of volumes and of mass will give you an understanding of the figure no other drawing experience offers. For this study in weight and mass, you'll need an 18″ × 24″ sheet of white paper and an Ebony pencil, graphite stick, black crayon or black marker. Spend fifteen to thirty minutes on each drawing.

Drawing the human form demands an intuitive understanding of its structure. There are good books on how the body works and on human anatomy, and this knowledge is very helpful to the artist. However, there is no substitute for the kind of knowledge that can only be absorbed from actually experiencing the figure through gesture drawing or weight and mass drawing.

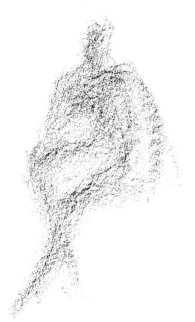

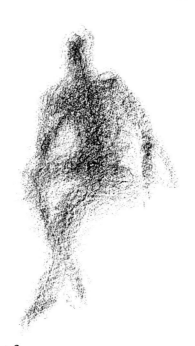

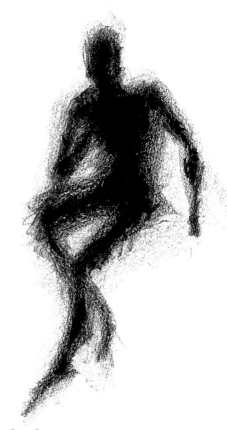

Step 1.
Begin with a gesture drawing. Catch the action. Look for the big curves, the disposition of the body's masses.

Step 2.
Delineate the component shapes of the body and identify its constituent volumes.

Step 3.
Begin filling in the volumes with matter by scribbling longer and harder where the body is thicker, bonier, heavier or more massive. The finished drawing should give a good impression of the body's masses.

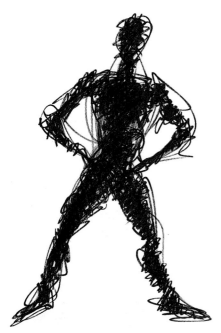

Weight and mass drawing can be done in a variety of materials. This drawing was done with black crayon. Soft lithographer's crayons are also good.

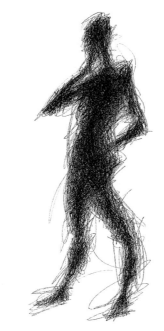

This drawing was done with an Ebony pencil.

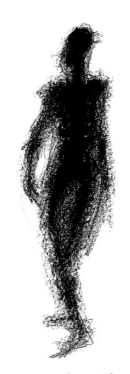

This drawing was done with a marker.

Chapter Three
SEEING

All gifted draftsmen seem to have in common an almost infallible eye. We once watched a demonstration by an illustrator who was known for his uncanny drawing skill. He was drawing from a model. He first made a mark near the very top of his paper, then another at the bottom. He began the top of the head at the upper mark and rapidly worked his way down, finally hitting the big toe of the foot exactly on the bottom mark. Of course, everything in between was accurate. This feat is simple enough to describe but exasperatingly difficult to execute. Another artist of even more prodigious abilities draws sweeping, complicated passages without lifting his charcoal from the paper. In a single line, he can draw the model's out-thrust hip, then follow down the leg, catching each curve of muscle and jut of bone, turn at the foot, articulate the toes, cross over the overlapping second foot and up the other leg, all with flawless precision.

As inspiring as these virtuoso performances are, it should be reassuring to all that the eye and hand can be trained to perform such feats—not necessarily with the same style, grace or intensity as that of the most gifted artists, but with considerable accuracy. In fact, drawing accurate proportions is probably the aspect of draftsmanship that improves most with training and practice. Proportions are relationships—one part to another and all the parts to the whole. Although all good drawing requires accurate proportions, when the human form is the subject, accuracy is most important. The average viewer knows the human form intuitively. Proportions are the one area of art that everyone feels competent to criticize: "That's a nice drawing, but isn't the (fill in the blank) a little too (fill in the blank)?" Badly drawn proportions interfere with the viewer's appreciation of other qualities in the picture. When proportions are drawn

correctly, it's hardly even noticed—which is just what we want.

In this chapter, you are going to learn three simple strategies for taking accurate measurements. All of them employ the drawing tool as a measuring instrument in a method called *sighting*.

To demonstrate the immediate benefits of sighting, a student was asked to make an outline drawing of a model. The left-hand drawing (page 23) was the result. After an explanation of just one of the sighting techniques—finding the midpoint—she was asked to try again. The difference is remarkable. In the first case, the torso is unnaturally elongated and the legs shrunken. These defects are corrected in the second drawing, producing not only the proper size relationships but also a natural and graceful pose. It is an altogether more lifelike drawing than the first.

Because we know the head is placed above the shoulders, we tend to want to draw it that way.

True seeing means ignoring logic and responding to what our eyes tell us.

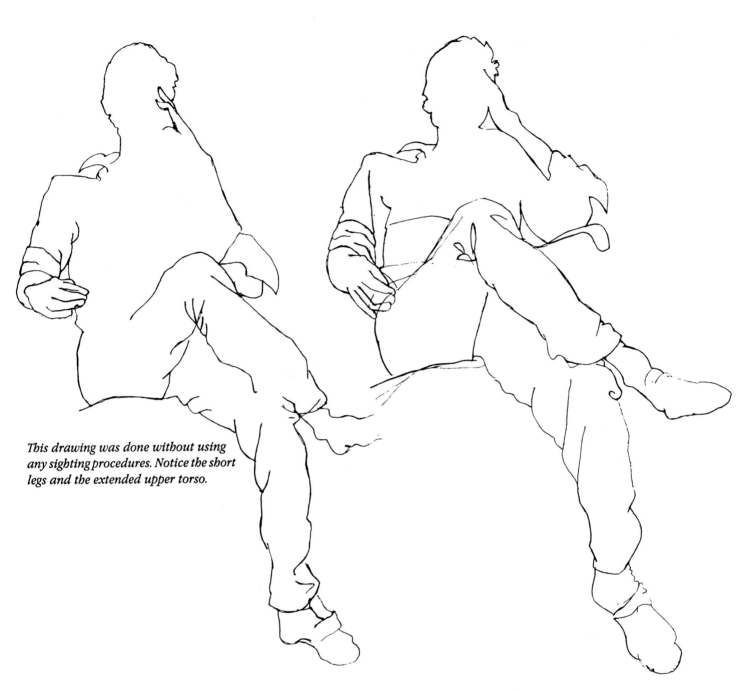

This drawing was done without using any sighting procedures. Notice the short legs and the extended upper torso.

This drawing was done by the same student after finding the midpoint. Here the leg-to-torso relationship is more credible and the pose seems more natural.

Sighting

Most of us have a pretty good eye, more accurate than we realize. When we judge which of two pieces of cake is larger, or whether a floor is level, or whether a couch will fit through a doorway, we are relying on the same estimating skills used in drawing. Now we're ready to add to these some objective measuring strategies.

By holding your drawing tool in front of you and sighting along it, you have a valuable aid to accurate proportions. The procedure is this: Grasp your pencil between your thumb and first two fingers so that most of it extends vertically as shown. Hold it at arm's length, elbow locked. Now, holding your head still, one eye closed, sight along the pencil at your subject. This will be the basic position for the measuring techniques we call sighting.

The term *pencil* is used for simplicity's sake, but all of the following applies as well to pen, crayon or charcoal.

Three sighting strategies:
- Finding the midpoint
- Using plumb and level
- Taking comparative measurements

These immensely useful and versatile procedures yield immediate and effective results. You'll learn to measure proportions as you *see* them rather than as they actually are. Of course, we know that objects appear the way they do because of their underlying form, but we are going to draw what we see *rather than what we know*. Using the sighting methods of midpoint, plumb and level, and unit of measure will prove to be a direct means of obtaining accuracy in your drawing.

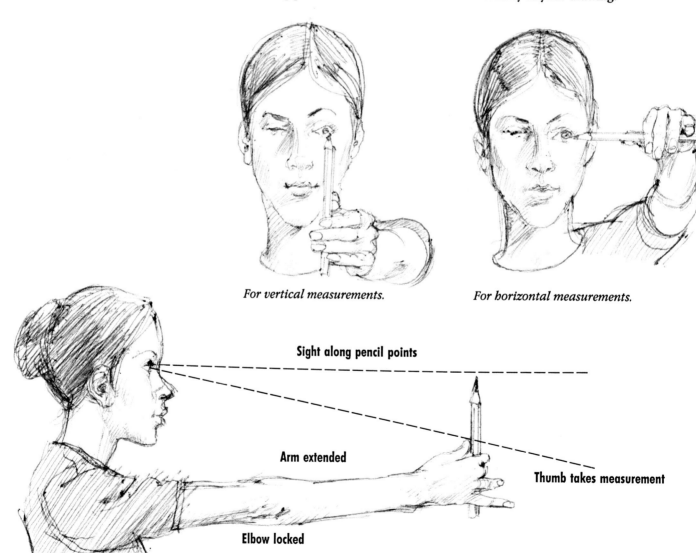

For vertical measurements.

For horizontal measurements.

Sight along pencil points

Arm extended

Thumb takes measurement

Elbow locked

Finding the Midpoint

Think of your subject as a shape that you divide at the midpoint. The half above the midpoint must fit into the top 50 percent of your drawing area and the half below must fit into the lower 50 percent. Studiously finding and using the midpoint in this way ensures that each half of whatever you divide will be in proportion to the other.

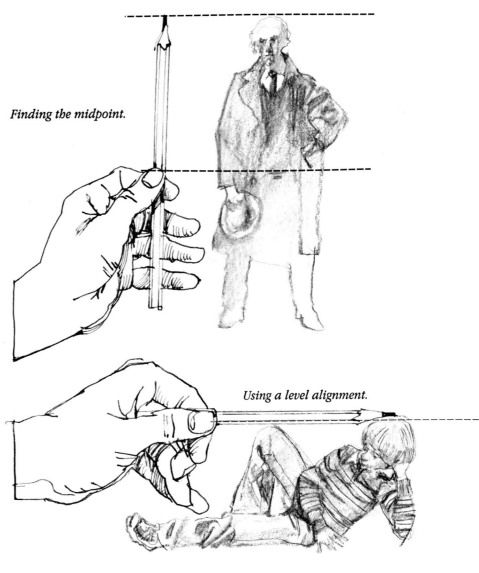

Finding the midpoint.

Using Plumb and Level

Using your pencil like a carpenter's tool, you can establish the vertical and horizontal alignments of your subject and transfer them one at a time to your paper. This strategy is especially useful in establishing the action of your pose.

Using a level alignment.

Using Comparative Measurement

In this strategy you measure with your pencil the length of one part of your subject and compare it to the length of another part. The head is a commonly used unit of measure, for instance, and might be compared to the upper arm length or to shoulder width. This procedure is basic to finding proper proportions.

Measuring the head to compare with another part.

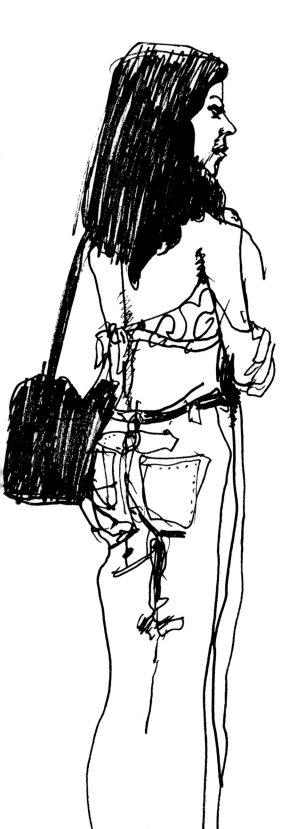

Finding the Midpoint

Finding the midpoint starts you off on your drawing with a major proportional problem solved. Your subject will have been divided into two manageable halves, and, more important, they'll be placed correctly on your page. This measurement is used in the early stages of the drawing, probably only once, and it will save you a world of trouble later on.

To find the midpoint, first regard your subject—in this case a standing figure—as a shape. Lightly and loosely sketch that shape the size you desire on your page. This sketch need be little more than an amorphous indication, but make sure you clearly indicate the top and bottom of the shape. Now study your subject again and estimate the halfway point between the top of the head and the bottom of the feet. Make a mental note of that spot.

To see if this really is the midpoint, do a sighting with your pencil. Align the point with the top of the model's head and place your thumbnail against the pencil at the point that aligns with your midpoint guess. Now, keeping your thumb in place, lower your pencil tip to the midpoint and see if your thumb aligns with the bottom of the model's feet. If it does, you've succeeded in dividing the model in half, and your eye is very good. If it doesn't, take another guess and try again; your eye will improve with practice.

Remember to keep your head straight and your elbow locked in the same way every time you measure. When you've found the midpoint, return to your paper and find the midpoint of the shape you've drawn. Mark that spot lightly, corresponding to the midpoint of the figure. Sketch it in. Now you've divided both your subject and your drawing into two manageable halves, your boundaries are set, and you're ready to proceed.

First indicate on your paper the general size and placement of your subject.

Find the midpoint of your subject and transfer it to the center of your placement shape.

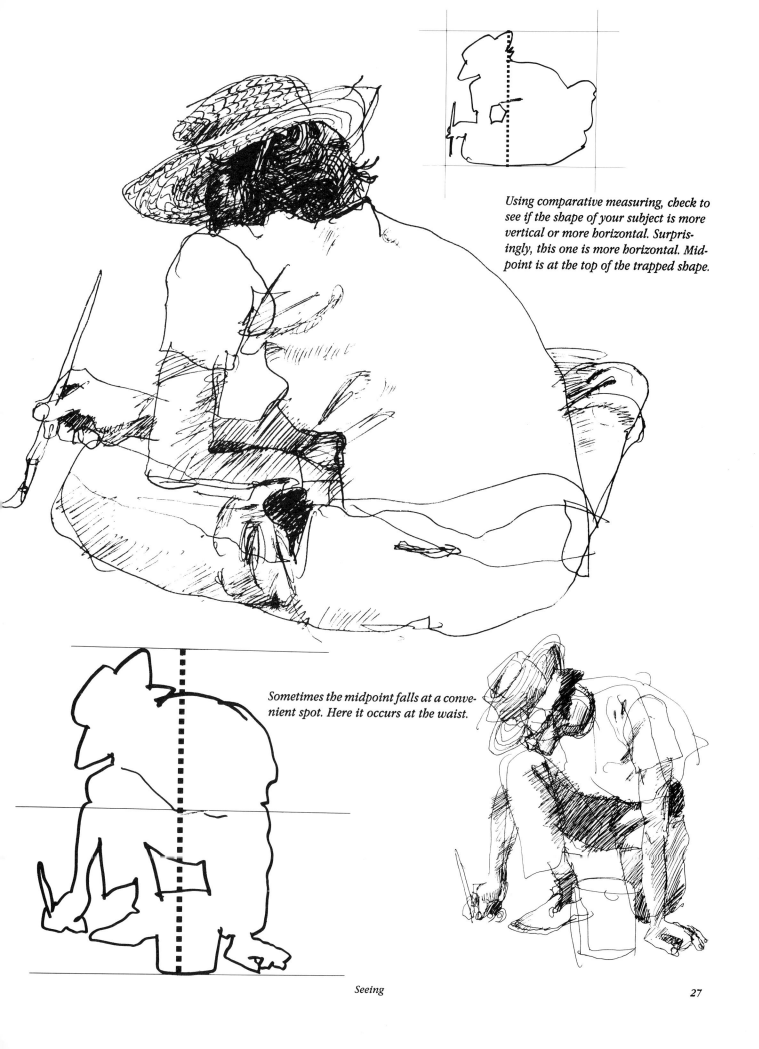

Using comparative measuring, check to see if the shape of your subject is more vertical or more horizontal. Surprisingly, this one is more horizontal. Midpoint is at the top of the trapped shape.

Sometimes the midpoint falls at a convenient spot. Here it occurs at the waist.

This figure is cut off at the ankles.

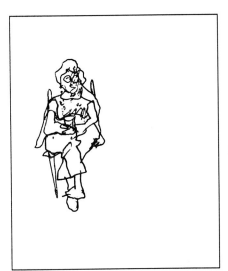

This figure is drawn too small in relation to the paper.

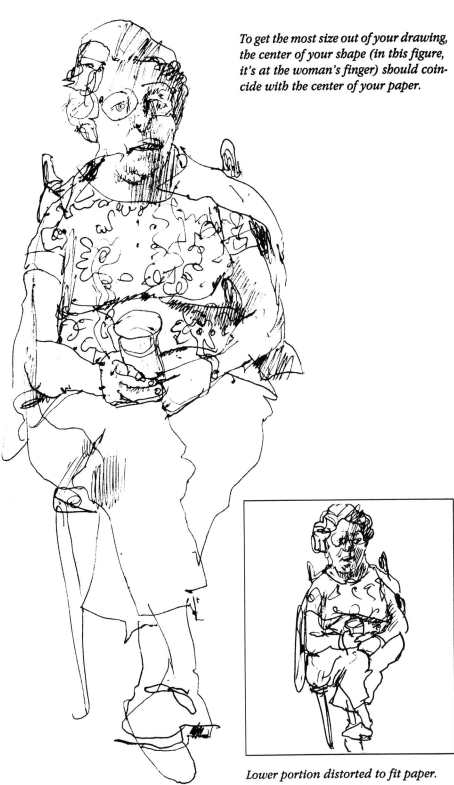

To get the most size out of your drawing, the center of your shape (in this figure, it's at the woman's finger) should coincide with the center of your paper.

Lower portion distorted to fit paper.

Basic Figure Drawing Techniques

Why Find the Midpoint?

One of the greatest values of finding the midpoint is that it helps you "place" your drawing on the page. Without those top, bottom and midpoint marks on your paper, it is difficult to draw a figure head to foot so that it just fills the area. Finding the midpoint solves the problem of running out of paper or leaving too much blank. If, with a few indications of head and upper torso, you find you have extended your drawing below the center mark of your paper, you will know you are drawing too large. If you end up above the center mark, you are drawing too small. In either case, you can quickly make the appropriate adjustments by restating.

Naturally, there will be times when you will want to fill the paper with only a part of the figure or to draw the figure quite small in a large empty space. Here again, finding the midpoint will help you place your subject exactly where you want it. If you wish, you can use finding the midpoint to further divide each half for more careful consideration.

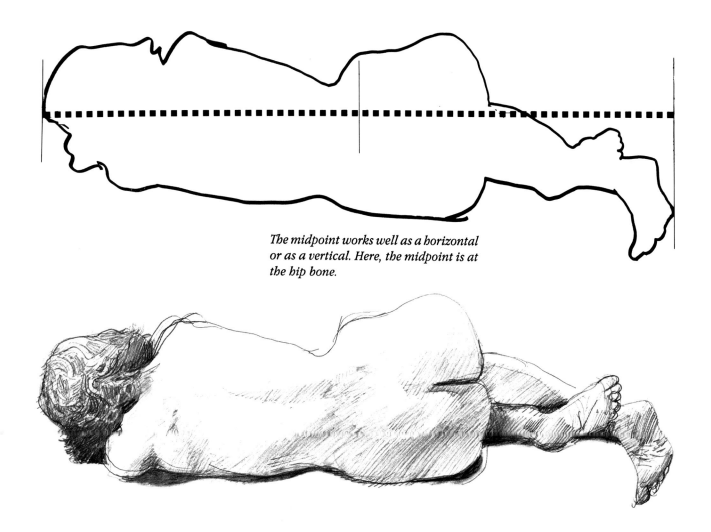

The midpoint works well as a horizontal or as a vertical. Here, the midpoint is at the hip bone.

Alignments — Using Plumb and Level

Proper use of alignments will capture the action of a pose. A plumb line is a vertical line, a level line is a horizontal one. All of us, with our sensory and balancing equipment, can judge verticals and horizontals quite accurately. Once again, using your pencil as a measuring tool, simply extend it in front of you over the subject and turn it this way and that at key points on the model to see what elements line up vertically and horizontally.

There is a specific action to the pose of the figure drawn below. We can gather a sense of that action by lightly sketching in a simple shape or gesture and then employing our plumb and level alignments. Any protrusion, such as a knee, shoulder, hip, elbow, toe or chin, is a potentially good place to use alignment measurements. On the fac-

ing page, you'll see how the plumb and level measurements used in the drawing below are diagrammed.

After making a preliminary sketch to place the figure, a level line was sighted from the point of the knee, determining that it was on a line with the model's nose. This was an important measurement because, beyond placing the nose, it gave the location for the entire head. This information was transferred to the drawing where horizontals and verticals were easily made parallel by using the edges of the paper as guides.

With this one alignment, it was simple to accurately sketch in the head, right shoulder and chair. The chair itself offered some alignment information. By following down its back and legs, you can see the various points at which it intersected the figure.

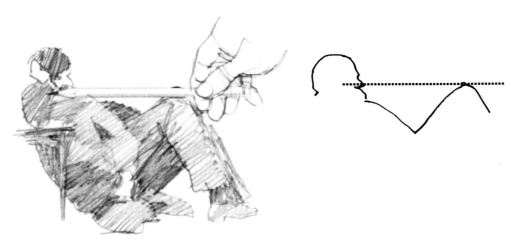

Nose and knee align.

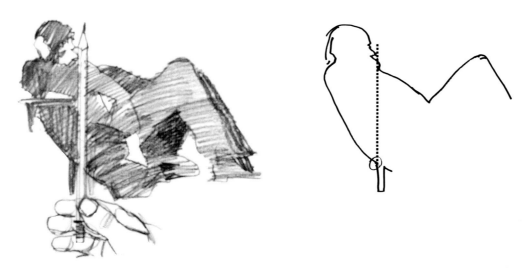

Nose and chair leg align.

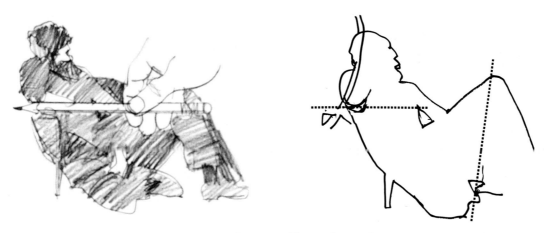

Instep and knee almost align.
Elbow and arm/leg intersection align.

The artist checked the plumb lines extending downward from the nose, and saw the point at which the model's back intersected the chair leg. An additional alignment established that the right elbow was level with the intersection of the left arm and leg. A plumb line extending downward from the knee helped locate the right foot.

You can see how a few plumb and level lines establish the action of a figure and help you draw better proportions. But don't think that drawing can or should be reduced to any step-by-step system. The use of alignments is one element in a busy potpourri of ges-ture strokes, restatements, blind drawing, smudging and erasing. How you use this or any other procedure will depend on your purpose at the time. The more accuracy you desire, the more plumb and level you will use.

For simple sketchbook studies, like the ones on these pages, you might use only one or two alignments. In such cases, look for unusual alignments, like a shoulder that is even with the knee, a jutting hat that is even with the bulge of a stomach, or a protruding lip that is even with the tip of a nose. Your eye will gradually learn to make these judgments automatically.

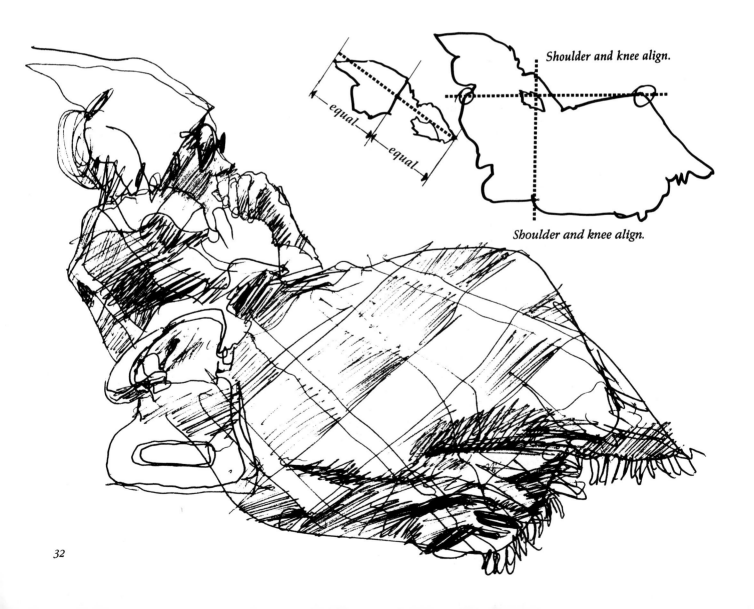

equal

equal

Shoulder and knee align.

Shoulder and knee align.

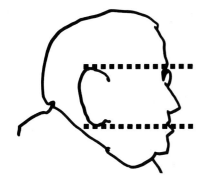

Ears usually align between the eyebrows and the base of the nose; however, this man's ears are unusually large.

After the nose, look for the next most forward protrusion of the face. In this case, it is the lower lip.

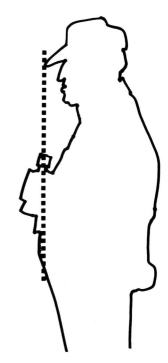

Look for alignments to extend from points such as elbows, noses, chins, shoulders, knees, or even as in this case, the bills of caps.

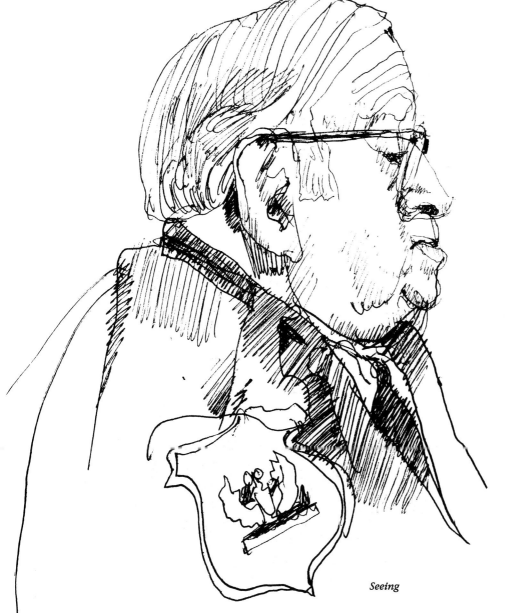

Taking Comparative Measurements

Taking frequent comparative measurements is a good way to check on proportions during the course of your drawing. Use your pencil as a measuring tool to compare the length of one part of your subject to the length of another part so you have an idea of their relative sizes.

Although you can use any part of your subject for comparative measurements, the head is a common unit of measure, so we'll use that as an example. Using the sighting method of pencil held upright, arm extended, one eye closed, put the tip of the pencil at the top of the head and mark the chin with your thumb. Now you have a means of comparing that length to other parts of the model—perhaps to the length of the upper arm or the width of the shoulder.

The distance measured on your pencil is for use *against the model*. It doesn't translate directly to your paper unless you are drawing what is called sight-size. More than likely your drawing is proportionately larger or smaller than you've sighted on your pencil. Your pencil measurement keeps relationships within the model straight in your mind.

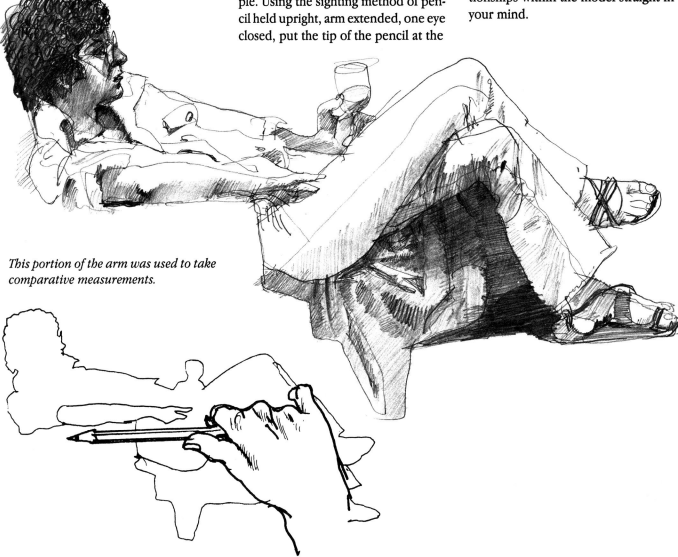

This portion of the arm was used to take comparative measurements.

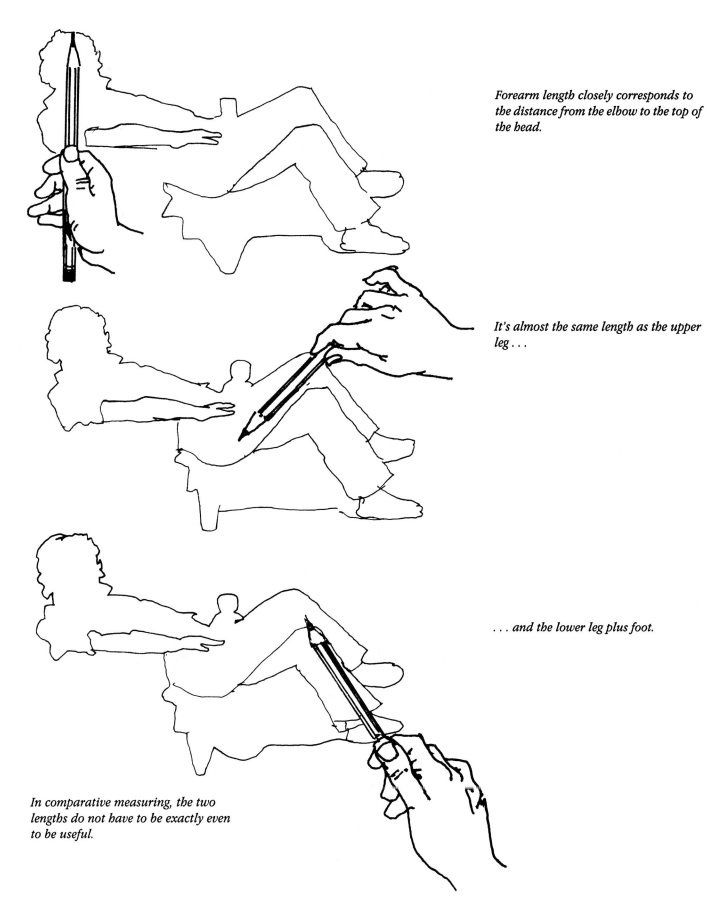

Forearm length closely corresponds to the distance from the elbow to the top of the head.

It's almost the same length as the upper leg . . .

. . . and the lower leg plus foot.

In comparative measuring, the two lengths do not have to be exactly even to be useful.

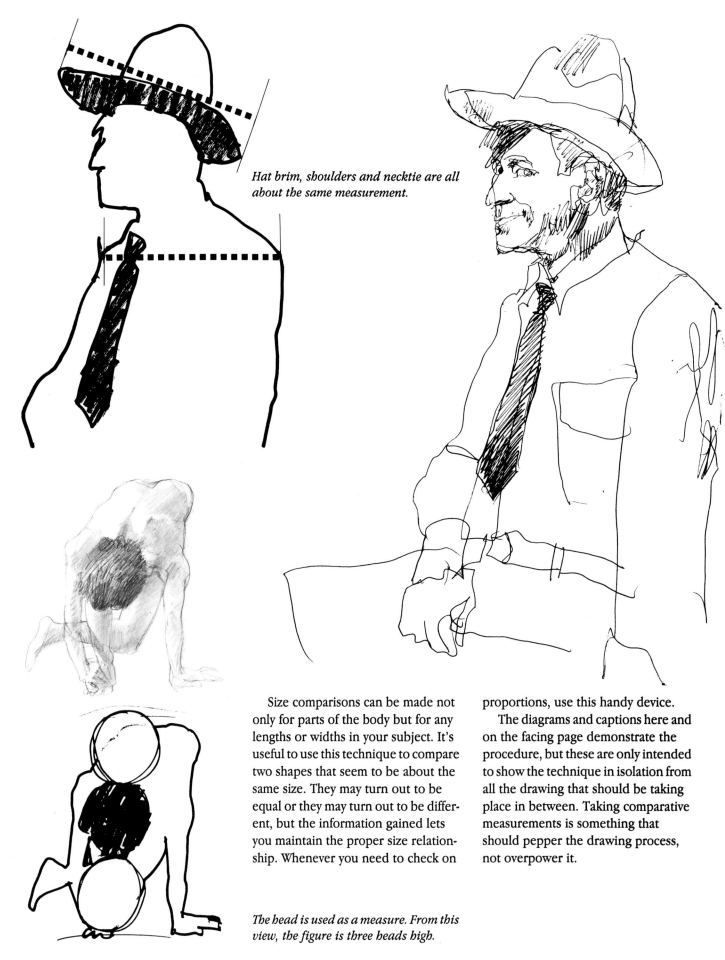

Hat brim, shoulders and necktie are all about the same measurement.

Size comparisons can be made not only for parts of the body but for any lengths or widths in your subject. It's useful to use this technique to compare two shapes that seem to be about the same size. They may turn out to be equal or they may turn out to be different, but the information gained lets you maintain the proper size relationship. Whenever you need to check on proportions, use this handy device.

The diagrams and captions here and on the facing page demonstrate the procedure, but these are only intended to show the technique in isolation from all the drawing that should be taking place in between. Taking comparative measurements is something that should pepper the drawing process, not overpower it.

The head is used as a measure. From this view, the figure is three heads high.

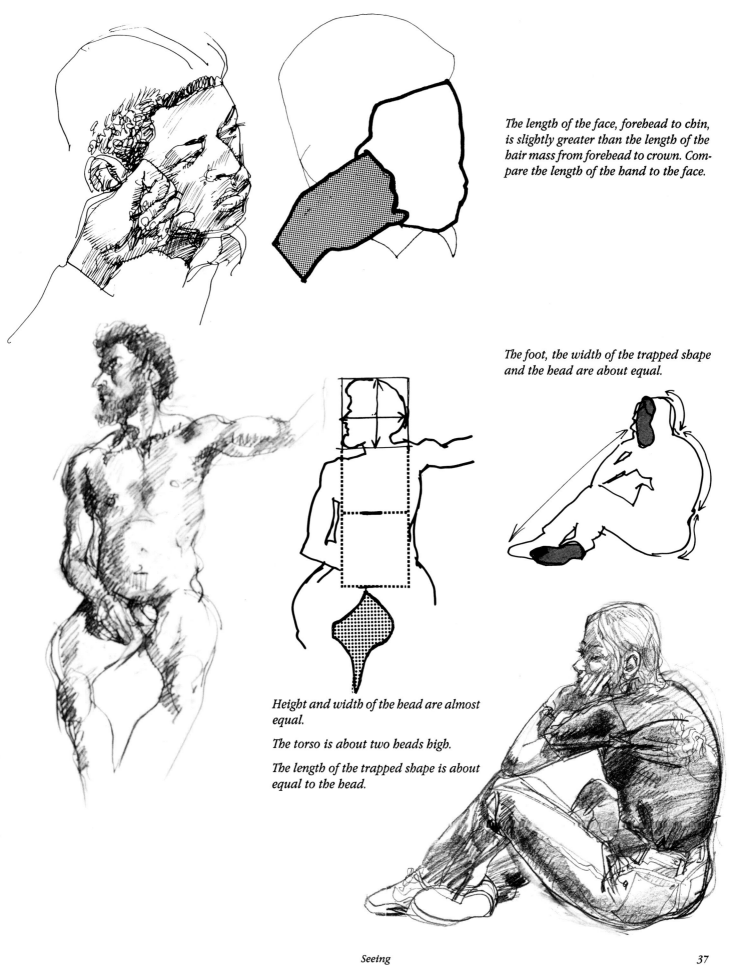

The length of the face, forehead to chin, is slightly greater than the length of the hair mass from forehead to crown. Compare the length of the hand to the face.

The foot, the width of the trapped shape and the head are about equal.

Height and width of the head are almost equal.

The torso is about two heads high.

The length of the trapped shape is about equal to the head.

Proportions

Proportions vary from person to person. However, classic Greek and Renaissance figures were eight heads in height, the head being used as the unit of measure. The Mannerist artists created elongated figures of nine or more head lengths. In nature, the average height of the human form is actually seven and a half heads, but the figure that measures eight heads long seems by far the best: It gives dignity to the figure and is convenient for measuring.

The classical male figure measured two heads across the shoulders and one and a half across the hips. The female width measurements are just the opposite of the male's.

Certain bones project on the surface of the body and become helpful "landmarks" when measuring proportion. These bones are always next to the skin. On a thin body they protrude, on a heavier one they show as dimples.

To draw people who will seem ideal to today's average viewer, we must set up a canon of proportions based on present-day taste. This canon need not necessarily be the same as the measurements of the present-day average man or woman. In the photograph silhouetted on page 40, the model is a well-developed male of average height. He is a "seven-head figure." Most people today, however, do not consider a seven-head figure tall enough to satisfy their concept of the ideal. They prefer the eight-head figure, which they feel is handsomer or more elegant.

Throughout the remainder of this chapter, you will find charts showing how the eight-head figure looks. To make this figure the same height as the seven-head figure we divide the height into eight parts. One of these parts serves as the basic head measurement unit. After drawing in the head, we position the other parts of the body along the vertical axis. The body alone, from neck to feet, now measures seven head units, instead of six. The parts are slightly elongated because of this, and as a result the figure seems more graceful and better proportioned.

Occasionally you will want to draw people who are obviously not average. If you want to caricature a person, or show that he is shorter than average or taller than average, you can do this very easily; retain the same width measurements used to draw the eight-head figure, but reduce the height to five or six heads, or increase the height to nine or ten heads. However, any departure from the eight-head formula should be deliberate.

Rely on your eyes for correct proportion. The head as a unit of measure is convenient and helpful while you are first learning figure proportions. But remember that you do not make figure drawings with a pair of dividers or a ruler. You make them with your pencil and your eyes. Actually, the only time you can literally measure the body and see how many heads long it is, is when the figure is standing bolt upright, in a position of attention. Any other time—which means most of the time—the figure or parts of it are foreshortened to some extent. Therefore, the only way to gauge proportions is with your eyes. If it looks right it is right. By all means study the charts that follow and fix in your mind the size of one part of the body compared with another, but put your ruler away when you start to draw. Never forget that skillful drawing is simply skillful seeing, transferred to the surface of your paper.

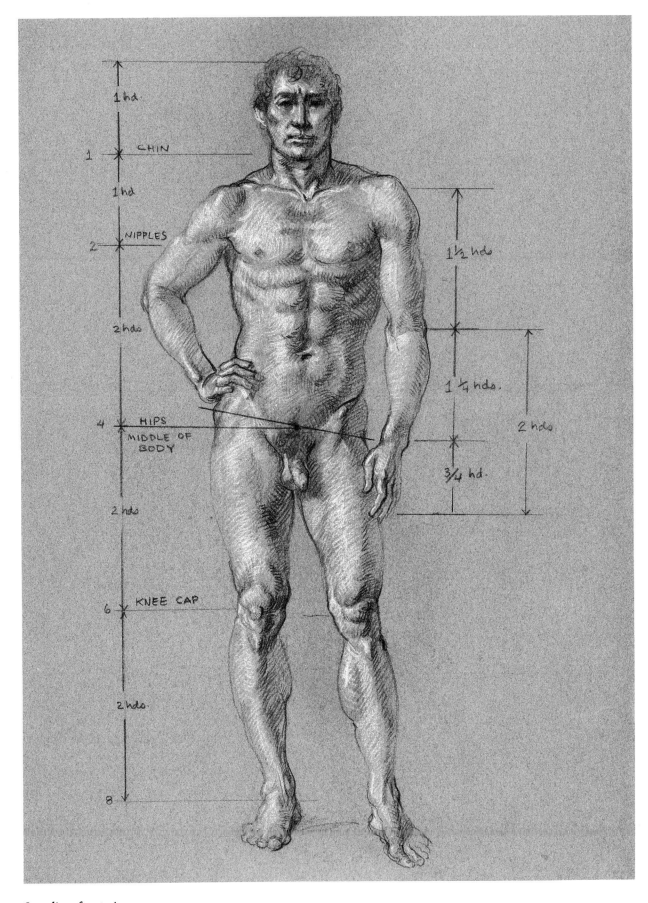

Standing, front view.

7-Head Division

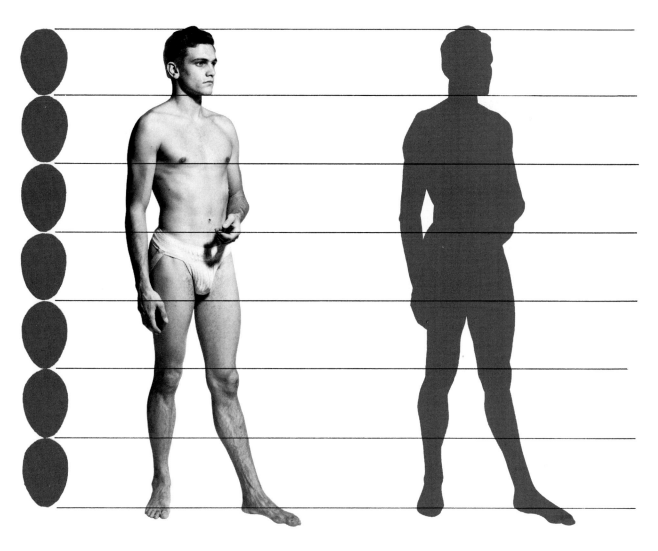

Step 1.

This model is a man of average height and good physical development. His total height is seven times the height of his head. If you ran into him in real life you would consider him well-proportioned. Yet when we draw him on paper, as the silhouette demonstrates, he seems to be much broader and stockier than most Americans think the ideal man should be.

Step 2.

The head is the basic unit by which the figure is measured. In the head-unit "ruler" above, the vertical height of the head is used to make vertical measurements of the body. Thus we say that the model is a "seven-head" figure.

8-Head Division

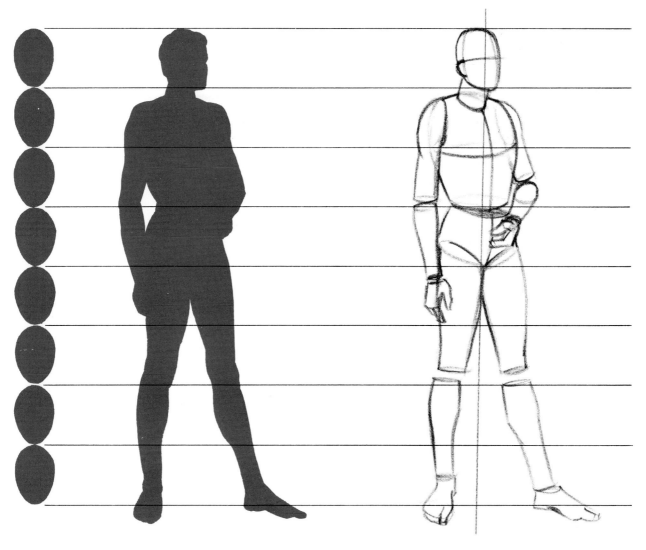

Step 3.

In the ideal figure the body is eight times the height of the head, as we have diagrammed above. Notice that although the total *height of this eight-head figure is the same as that of the seven-head figure at the left, the size of the head has been reduced in the eight-head figure. All the other parts of the figure have been elongated proportionately, so the figure now seems slim and graceful.*

Step 4.

Here the eight-head figure is presented in basic form. Study the relationships of the different parts of the figure, noticing how they are balanced on a vertical axis.

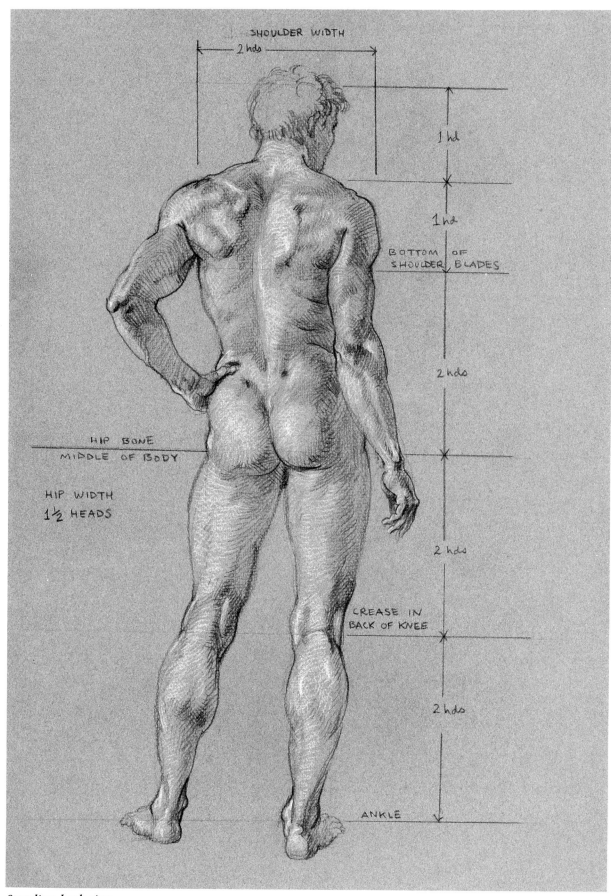

SHOULDER WIDTH
2 hds

1 hd

1 hd

BOTTOM OF
SHOULDER BLADES

2 hds

HIP BONE
MIDDLE OF BODY

2 hds

HIP WIDTH
1½ HEADS

CREASE IN
BACK OF KNEE

2 hds

ANKLE

Standing, back view.

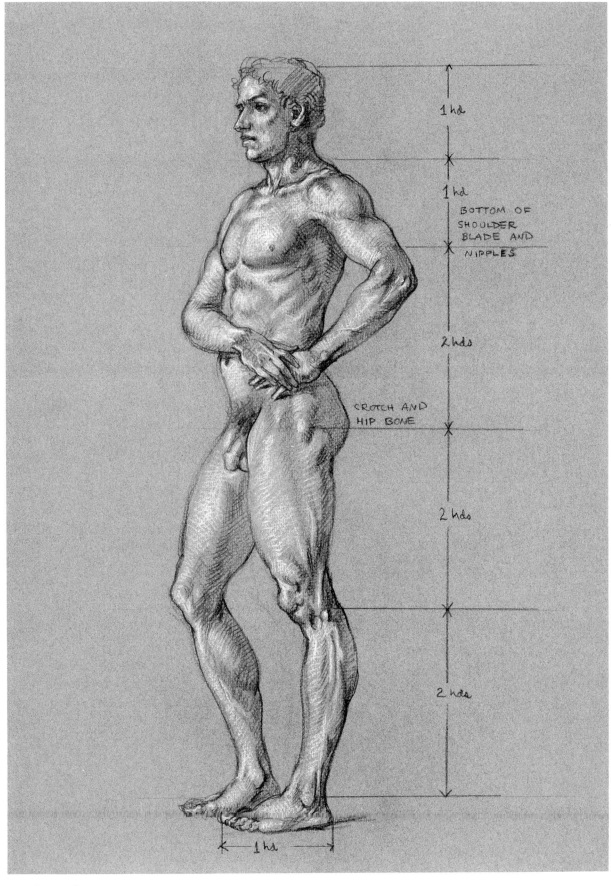

1 hd

1 hd
BOTTOM OF
SHOULDER
BLADE AND
NIPPLES

2 hds

CROTCH AND
HIP BONE

2 hds

2 hds

1 hd

Standing, side view.

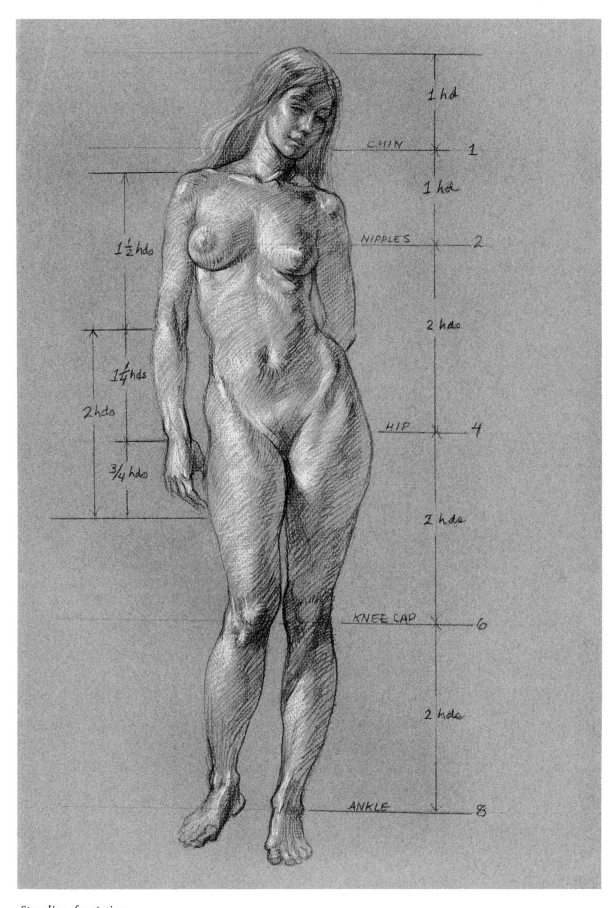

1 hd

CHIN \times 1

1 hd

NIPPLES \times 2

2 hds

1½ hds

1¼ hds

2 hds

HIP \times 4

¾ hds

2 hds

KNEE CAP \times 6

2 hds

ANKLE \times 8

Standing, front view.

Basic Figure Drawing Techniques

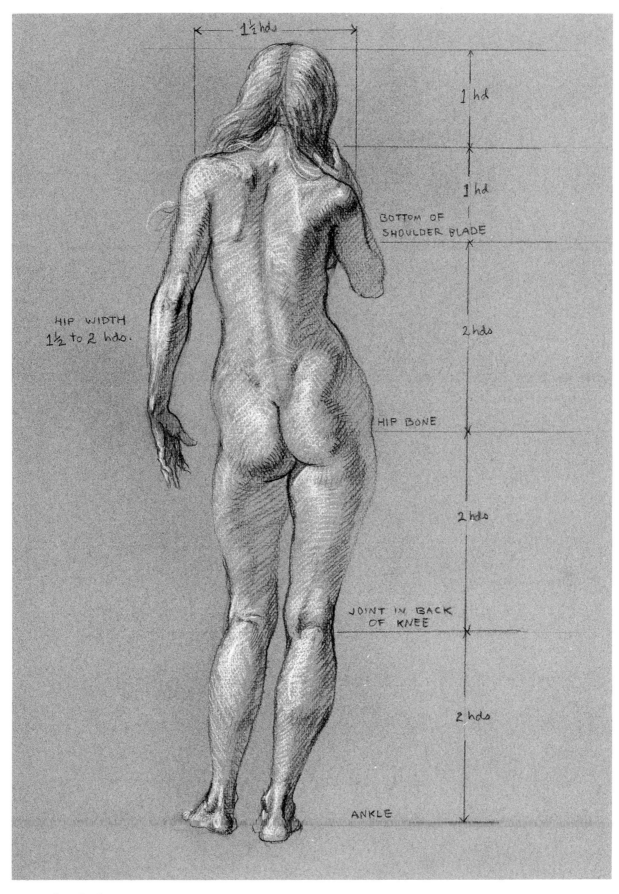

1½ hds

1 hd

1 hd

BOTTOM OF
SHOULDER BLADE

2 hds

HIP WIDTH
1½ to 2 hds.

HIP BONE

2 hds

JOINT IN BACK
OF KNEE

2 hds

ANKLE

Standing, back view.

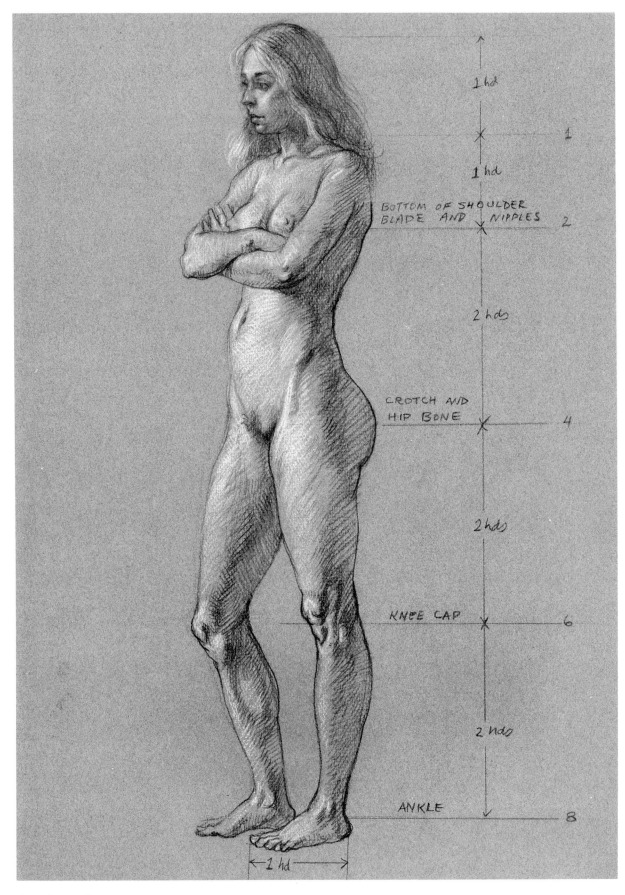

1 hd

1

1 hd

BOTTOM OF SHOULDER
BLADE AND NIPPLES 2

2 hds

CROTCH AND
HIP BONE 4

2 hds

KNEE CAP 6

2 hds

ANKLE 8

← 1 hd →

Standing, side view.

Basic Figure Drawing Techniques

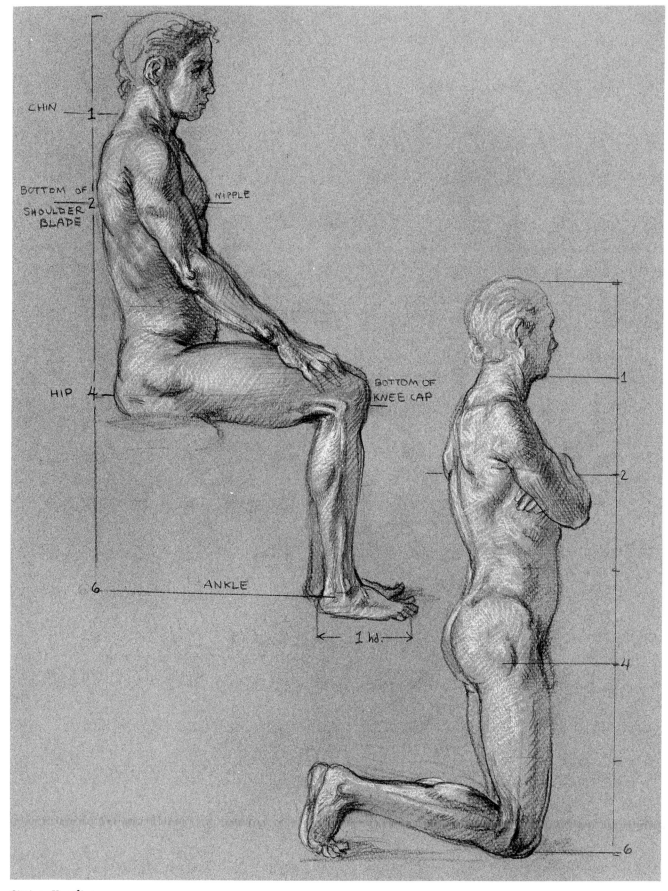

CHIN — 1

BOTTOM OF
SHOULDER — 2
BLADE

NIPPLE

HIP — 4

BOTTOM OF
KNEE CAP

6 — ANKLE

1 hd.

1

2

4

6

Sitting. Kneeling.

Chapter Four

FORM

The basic form figure on the right demonstrates an all-important principle of figure drawing—the human body is made up of simple, solid forms. The basic form figure represents the body in its essential masses. Every distracting element has been eliminated. Think of the form figure as if it were carved out of heavy wood; it is solid, three-dimensional. In this drawing the form figure has been pulled apart, or "exploded," to emphasize the various separate elements. They consist of head and neck; upper torso and lower torso; upper arms, lower arms and hands; and upper legs, lower legs and feet.

Compare the form figure with the photograph of the living model to its left. Note that the model and the basic form figure are similar in mass and construction, with the same association of parts. In both model and form figure the neck, the arms, the legs and the torso are essentially modified cylinders. The head is basically a simple sphere. The hands can be reduced to cubic forms, while the feet are combined cone and cube forms.

It is extremely important in the beginning to view the body in terms of these simple, basic forms, understanding the essential masses of the separate parts, and placing these in their proper proportions and relationships. For the present you can ignore hair and features, as well as the more subtle curves resulting from underlying bone and muscular structure. Once you can control and draw the basic forms properly, you will have little trouble drawing details.

As you learned in the previous chapter, the artist uses the head as the basic unit of measurement for the entire human figure. The head can be viewed both in terms of its height and its width. The height of the head, from the chin to the top of the skull, is the ruler by which all vertical measurements are made, but it is also convenient to use the width of the head for horizontal measurements. The shoulders, for instance, are three head widths across.

If you look at the people around you in real life, you will see that they differ considerably in proportions. One man has a head that we think is large for his body, another has a head that seems smaller than normal. The great majority of people, however, are reasonably similar in proportions and shape at any given age.

On this basis we can easily arrive at average proportions for the adult figure. But there is a distinct difference between the average and the ideal. Artists have always sought to discover the perfect figure. The Greek sculptors, for example, established a set of proportions for their idealized figures of gods and goddesses. In the same way, later artists, such as Leonardo and Durer, set up their own canons of proportions for the ideal figure. The concept of the ideal changes from nation to nation, and from period to period.

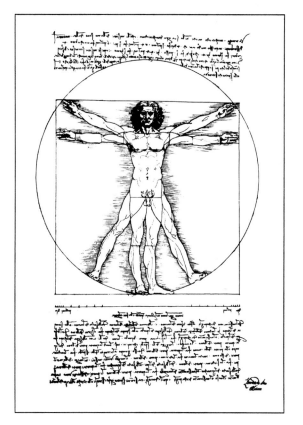

Leonardo da Vinci's eight-head human proportions.

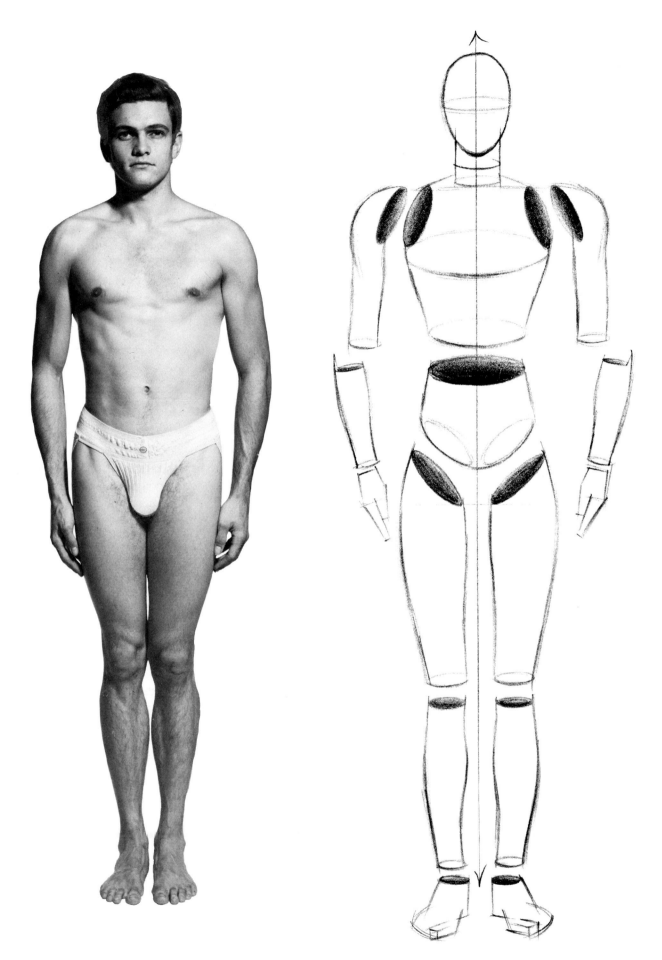

Drawing the Basic Figure

The drawings on these two pages show you how to get started drawing the basic figure. The first step is to study the model or photograph from which you are about to draw. Then begin to lay in the preliminary sketch lines that indicate the size, proportions and gesture or action of the figure. The lines don't have to be exact as you begin to draw. They are simply "starters," many of which will either be covered up or erased as the drawing develops.

Whether you're drawing the male or female figure, use the same basic approach. First, sketch in the free-flowing lines that indicate the gesture. Then look for the proportions, which way the shoulders and hips tilt, and which way the head is turned. Note the characteristic differences between the male and female figures. The female's shoulders are narrow and sloping, the hips wide. The male is broad shouldered and relatively narrower in the hips.

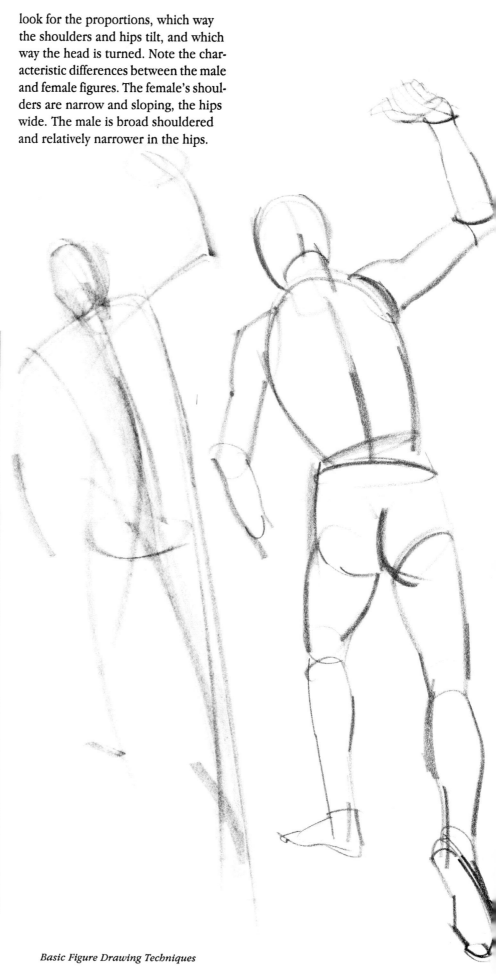

Basic Figure Drawing Techniques

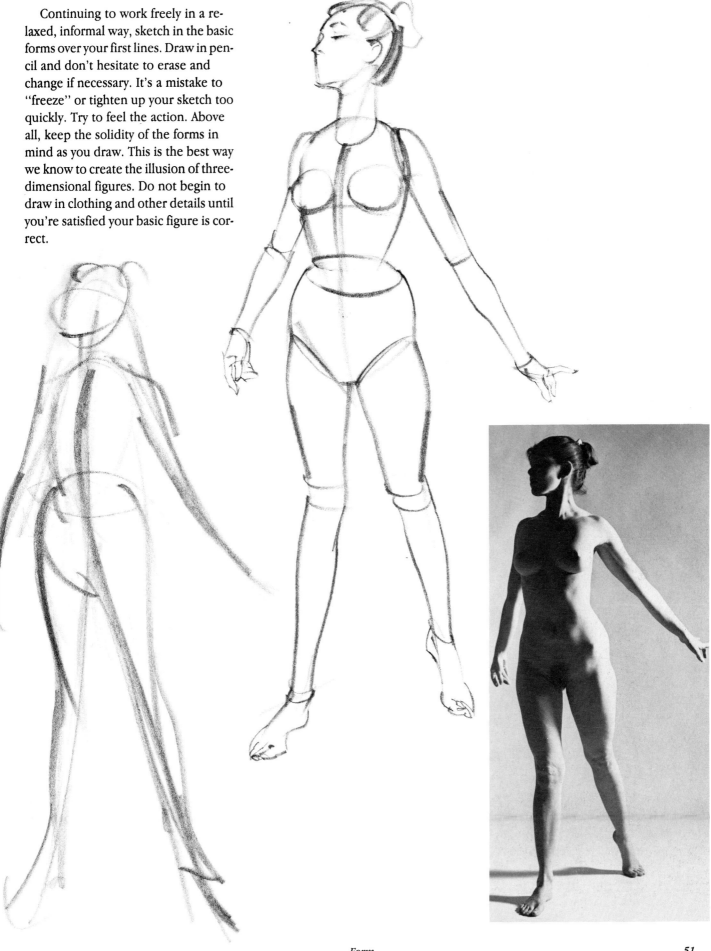

Continuing to work freely in a relaxed, informal way, sketch in the basic forms over your first lines. Draw in pencil and don't hesitate to erase and change if necessary. It's a mistake to "freeze" or tighten up your sketch too quickly. Try to feel the action. Above all, keep the solidity of the forms in mind as you draw. This is the best way we know to create the illusion of three-dimensional figures. Do not begin to draw in clothing and other details until you're satisfied your basic figure is correct.

Construction

It is helpful to reduce all objects to their simple, basic forms of cube, cone, sphere or cylinder. This can be done very easily even when the object seems quite complicated. On the following pages we will demonstrate how to think of the torso, arms and legs as modified cylinders, the hands and feet as cubic shapes, and the head as a simple sphere. If you can draw the basic forms, you can draw the human body.

Step 1.

The human torso is essentially two forms joined together on a flexible spine that permits movement in all directions. The upper form is approximately twice as high as the lower.

Step 2.

In order to visualize the relationship of these two forms, get two ordinary tumblers, one twice as high as the other. Like these two glasses, the two forms of the human torso are essentially simple cylinders.

Step 3.

This is the way we would draw these two simple, glass cylinders. If you think of the glasses as the upper and lower portions of the torso, and draw the glasses through, you will have no trouble visualizing the torso itself.

Step 4.

In this drawing you see how the two portions of the torso fit inside the two glasses. The torso forms look convincingly three-dimensional because they occupy the volume of space you have created by drawing the glass cylinders through to the other side.

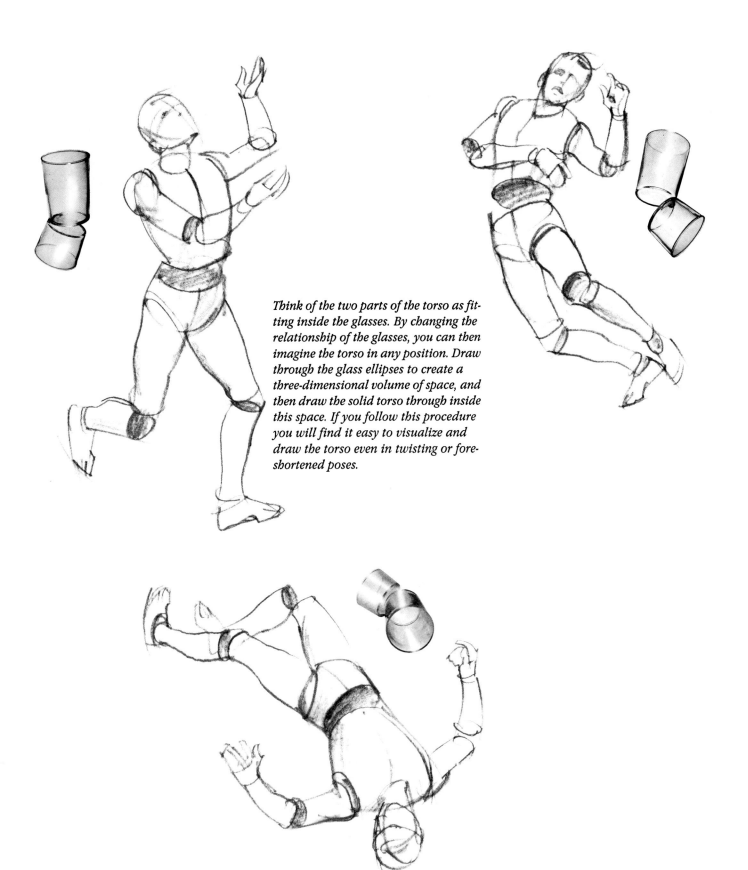

Think of the two parts of the torso as fitting inside the glasses. By changing the relationship of the glasses, you can then imagine the torso in any position. Draw through the glass ellipses to create a three-dimensional volume of space, and then draw the solid torso through inside this space. If you follow this procedure you will find it easy to visualize and draw the torso even in twisting or foreshortened poses.

The Leg

Like the arms, the two sections of the leg are modified cylindrical shapes, but are even longer and heavier than the arms. The major difference is that the joints of the arms and legs are hinged in opposite directions. Otherwise, the same approach can be followed when drawing the arms and legs, visualizing them first as glass tumblers. Once you have determined the degree of fore-shortening involved in the position of each section, you can easily modify the cylindrical shapes to resemble the contours of the limbs.

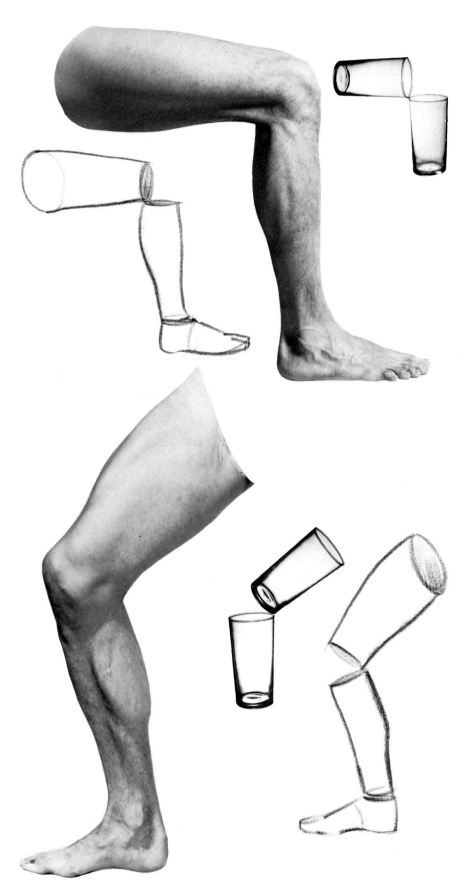

The Foot

While the underlying structures of hands and feet are very similar, their outward shapes differ in shape and proportion. The foot is approximately as long as the head is high. The upper portion of the foot can be reduced quite logically to a cone that has been cut off at the point where the top of the foot meets the ankle. This cone is not symmetrical; it has a much sharper angle at the back, where it meets the heel, than it does at the front, where it slants down to meet the toe form. The toe form and the entire sole of the foot is best considered a thin, cubic form. This approach to the foot will serve for your present drawings. The important thing now is to realize that the foot is a solid, three-dimensional object.

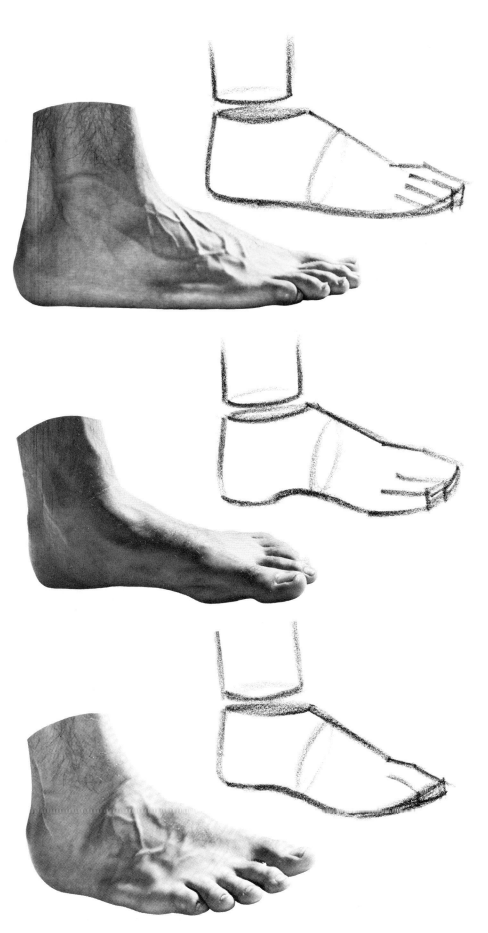

The Hand

The hand, at first, looks complex. It too, however, can be reduced to basic shapes. For the present, interpret the hand as a combination of simple forms that represent the real hand with reasonable accuracy. At the right, second from the bottom, the hand is treated as a wedge-shaped cube divided into two sections. The upper, broad section of the cube symbolizes the palm; the lower, tapering wedge suggests the mass of the fingers. The wedge of the palm, viewed alone, is a nearly perfect square. The finger wedge is about as long as the palm wedge. The visible part of the thumb is about the length of the little finger.

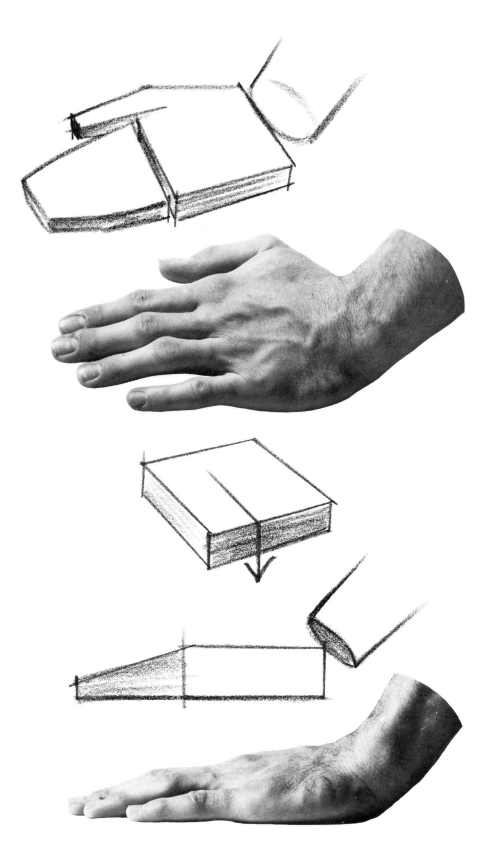

Basic Figure Drawing Techniques

The Arm

You can easily visualize the upper and lower parts of the arm as modified cylinders, represented by the shapes of two drinking glasses. The shapes are longer and slimmer than those representing the torso, but the principle is the same. As illustrated here, the cylinders can be placed in any position that might be assumed by the arm. It is the shape of the cylinder's ellipse that determines the degree of foreshortening involved in the pose. This is why it is so important to draw through—draw all the structural lines of the geometric forms that compose the figure.

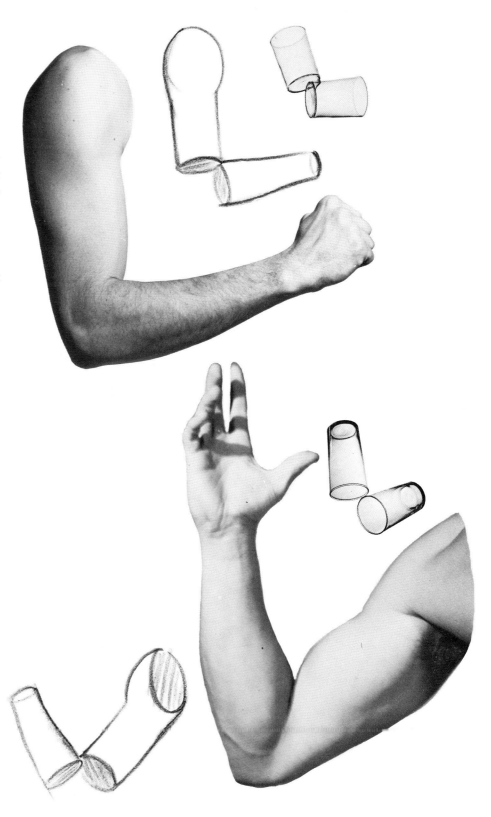

Movable Parts

Important points at which motion occurs in the body are indicated by white dots on the figure at the right. The individual parts are connected by three distinctly different types of joints: 1) the ball-and-socket joint, which appears at the shoulders, hips, wrists and ankles; 2) the hinge joint, found at the knees and elbows; and 3) the flexible column, a term used to describe the spine and the neck.

Each of these joints varies considerably in the type of motion it allows. The ball-and-socket joint is extremely flexible and permits rotary motion in all directions, although the amount of motion depends on the construction of the individual joint. The hinge joint at the elbows and knees may be visualized as a flat disk. This disk provides the flexibility-plus-rigidity that these members need to act as adaptable levers. The upper and lower arms and legs can be fixed in any relationship on

a straight line, but all sideward motion is prohibited. The action of these two joints is illustrated on the following page.

The third type of joint is the flexible column of the spine. This connects the upper and lower halves of the body. The spine is involved in any motion that requires shifts in weight, such as walking, running and jumping. Since the spine is highly flexible, it permits not only rotary motion in all directions, but also twisting motion throughout its entire length. The upper part of the spine is the neck, which controls all motion of the head.

The diagrams on this page are intended to remind you of the various possibilities that these three different joints provide. However, you can study the possibilities and limitations of motion in the human body best by experimenting to see how the various portions of your own body move. Test out these diagrams for yourself.

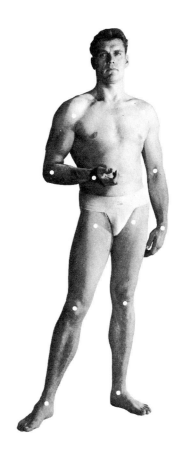

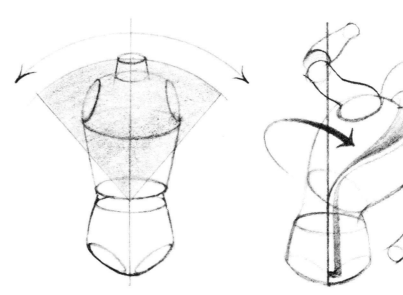

Although the upper portion of the body has the greater range of motion, its side-to-side movement is limited as shown here.

The spine is so constructed that it can bend and twist at the same time, as the illustration demonstrates.

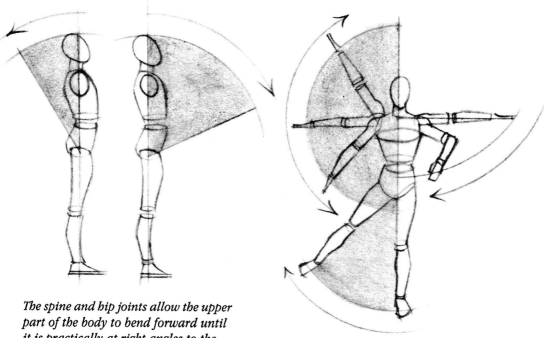

The spine and hip joints allow the upper part of the body to bend forward until it is practically at right angles to the lower. The backward motion is more limited.

The shoulder and the hip joints are both ball-and-socket rotary joints, but because of construction the shoulder joint is much more flexible than the hip joint. Motion of the shoulder joint covers a complete arc.

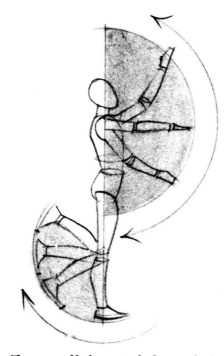

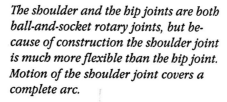

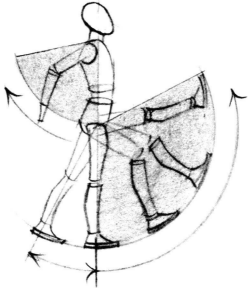

The sense of balance in the human body is well developed. If the arm reaches up, the lower leg will lift back to balance it.

This diagram shows the possible backward movement of the arm and the forward movement of the leg. Always take this reciprocal balance into consideration.

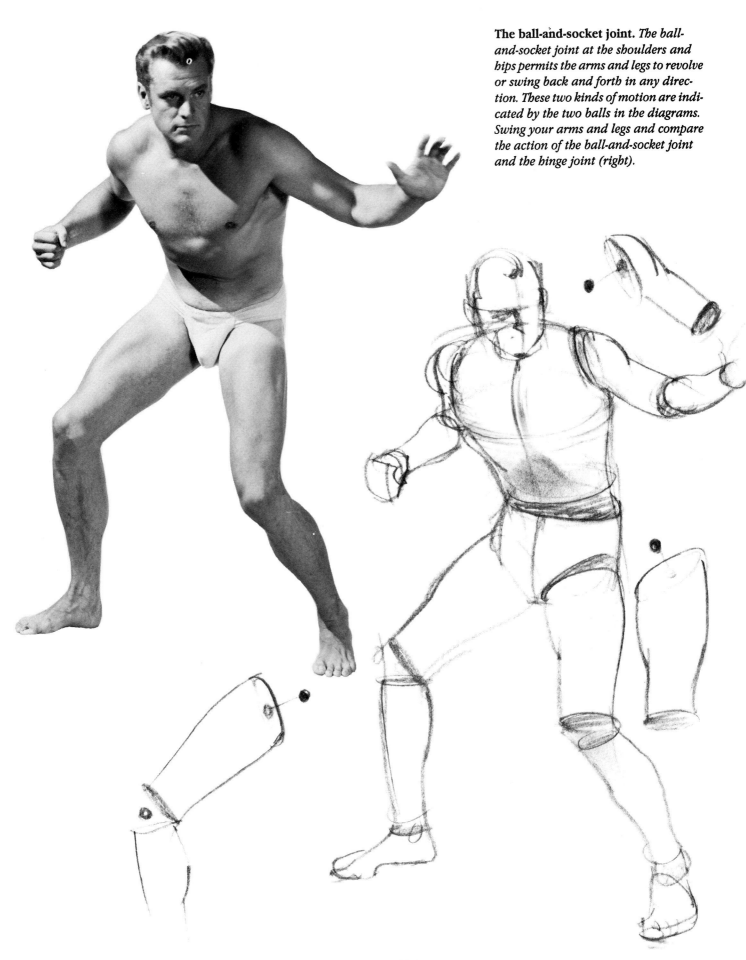

The ball-and-socket joint. *The ball-and-socket joint at the shoulders and hips permits the arms and legs to revolve or swing back and forth in any direction. These two kinds of motion are indicated by the two balls in the diagrams. Swing your arms and legs and compare the action of the ball-and-socket joint and the hinge joint (right).*

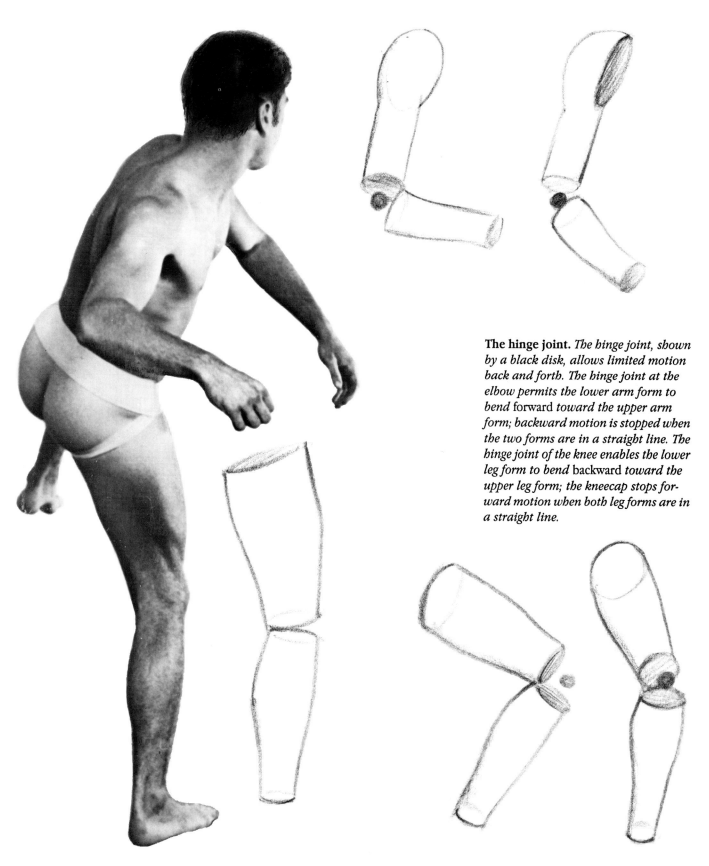

The hinge joint. *The hinge joint, shown by a black disk, allows limited motion back and forth. The hinge joint at the elbow permits the lower arm form to bend* forward *toward the upper arm form; backward motion is stopped when the two forms are in a straight line. The hinge joint of the knee enables the lower leg form to bend* backward *toward the upper leg form; the kneecap stops forward motion when both leg forms are in a straight line.*

Exercise in Motion

Draw several basic figures in a variety of poses. Remember to visualize the various parts of the figure in terms of the basic simple forms of cylinder, cube and sphere. Remember to use ordinary glasses to help you see how the ellipses look in the simple cylinders of the upper and lower legs. Remember to think of the head as a simple sphere. Remember the body's sense of balance. If you follow these principles, you will find it very easy to develop convincing drawings of the human figure in action.

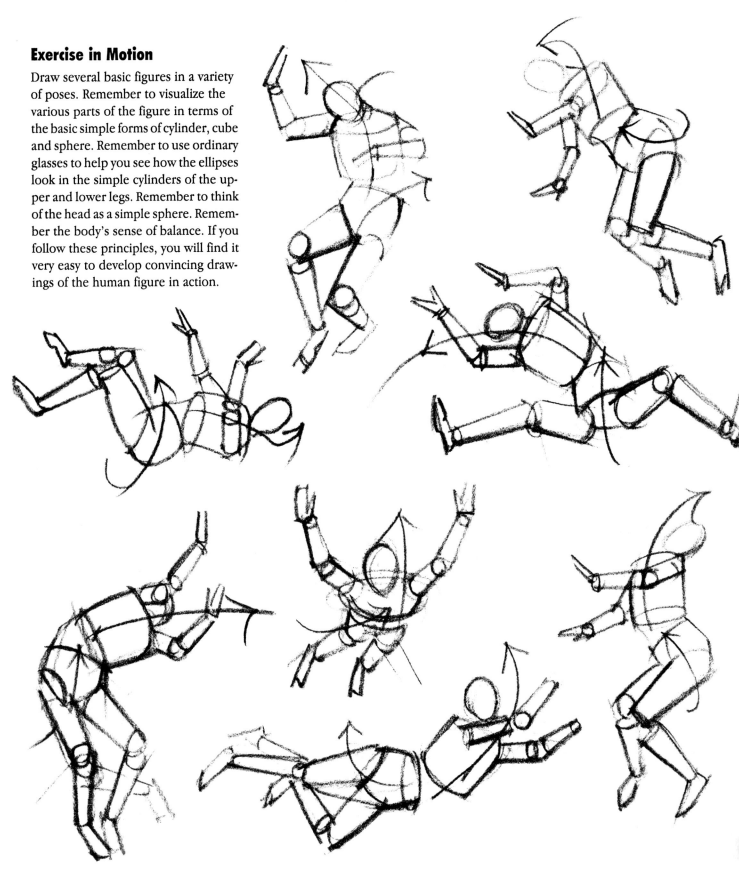

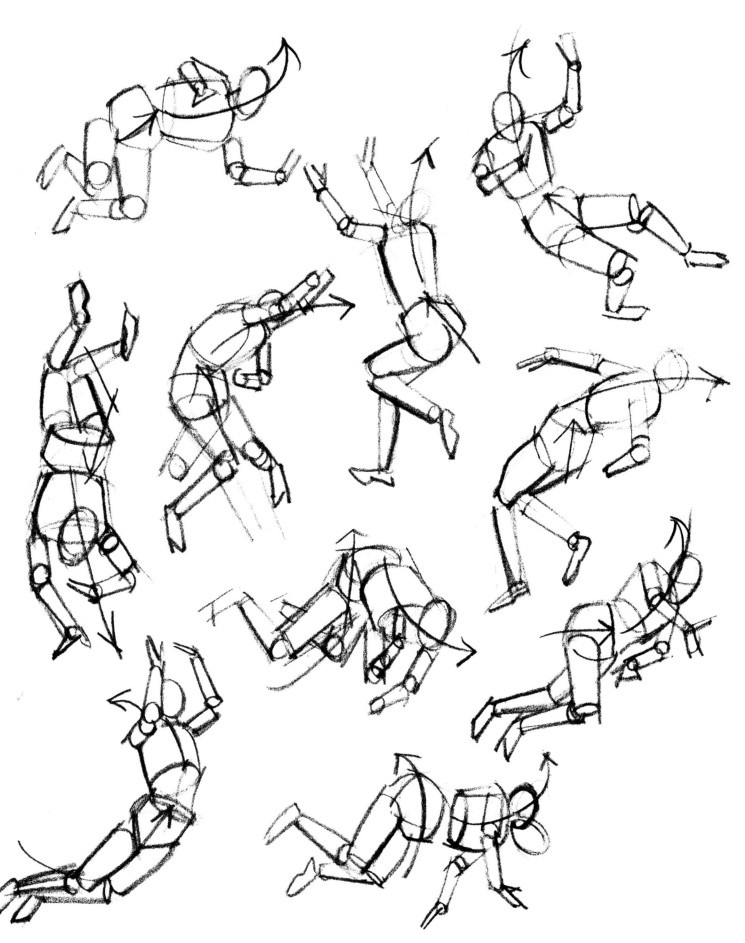

Foreshortening

When drawing from a model or a photograph, beginning with basic figure construction provides an excellent means of understanding and locating foreshortened forms or those parts of the body that are partly obscured from view.

Keeping in mind the simple, three-dimensional, component parts, draw the basic forms through completely, as though the figure itself were transparent like the drinking glass form illustrated earlier.

When you are satisfied that the construction is right, it is then a simple matter to erase those "invisible" parts and strengthen the visible parts as indicated in the stages above.

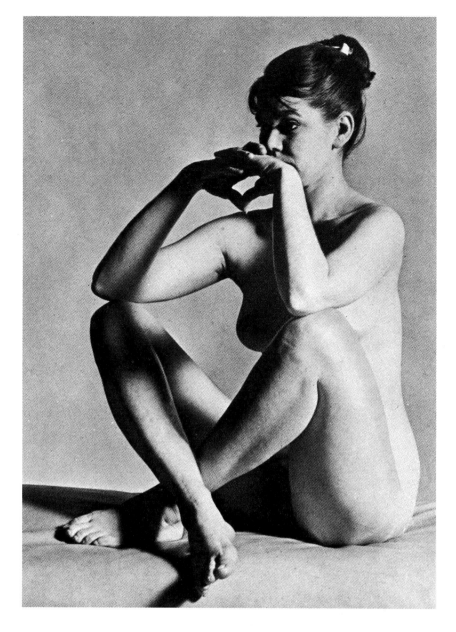

Even the most complicated poses can be reduced to the simple, solid forms that make them up.

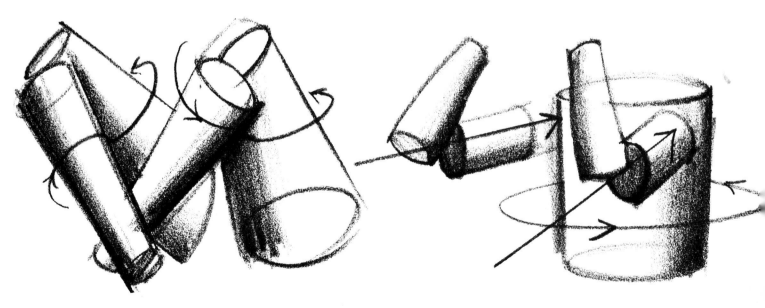

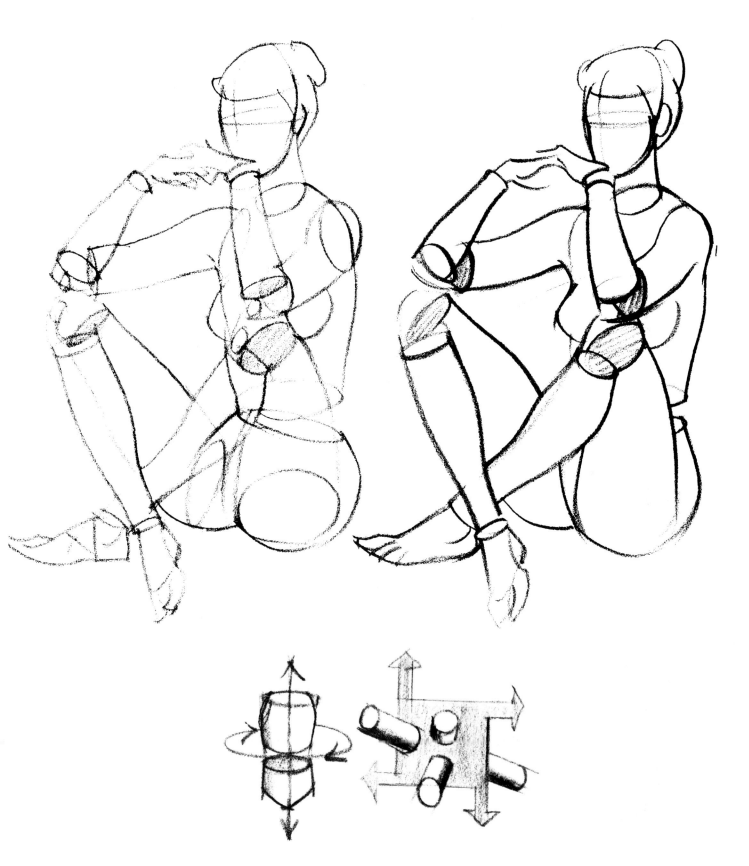

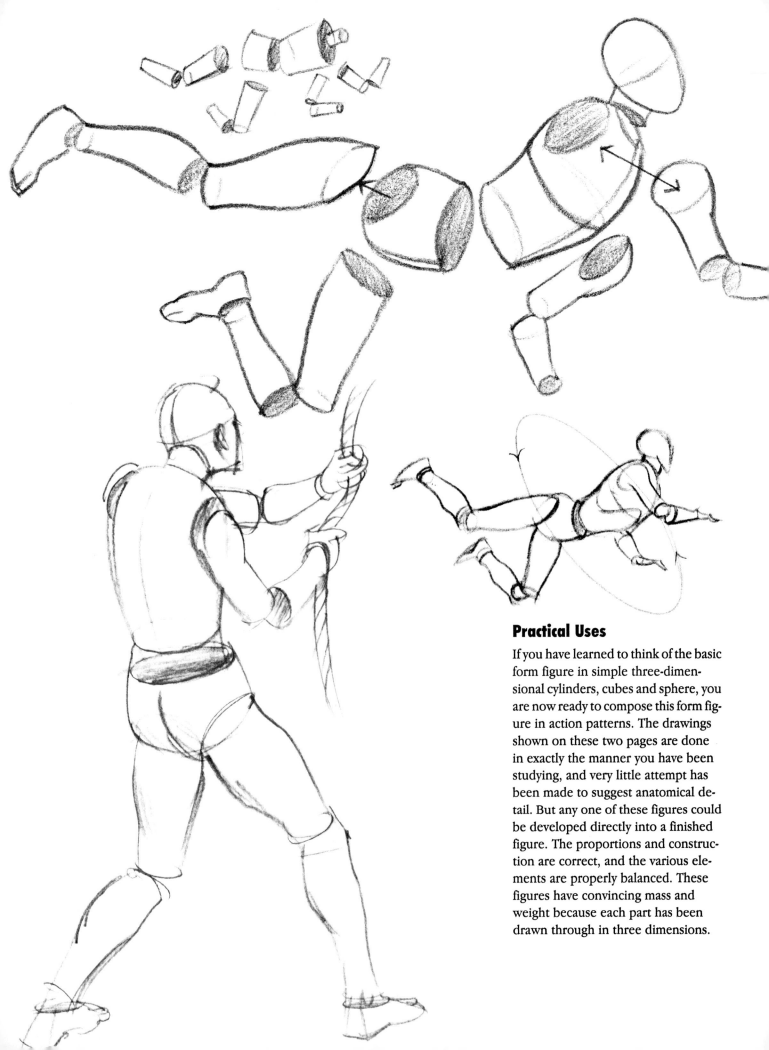

Practical Uses

If you have learned to think of the basic form figure in simple three-dimensional cylinders, cubes and sphere, you are now ready to compose this form figure in action patterns. The drawings shown on these two pages are done in exactly the manner you have been studying, and very little attempt has been made to suggest anatomical detail. But any one of these figures could be developed directly into a finished figure. The proportions and construction are correct, and the various elements are properly balanced. These figures have convincing mass and weight because each part has been drawn through in three dimensions.

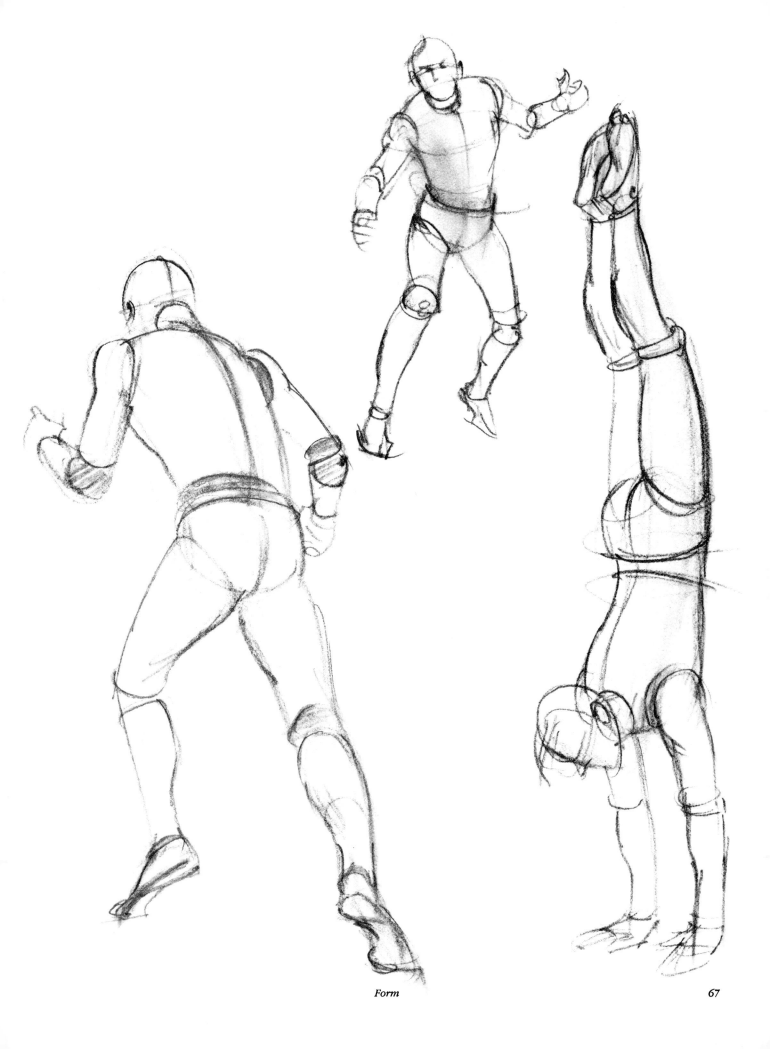

Form

Definitions

Drawing through. *The glass above has been drawn through to the other side; all the structural lines can be seen. In the same way, you must sketch in all the structural lines when you are drawing a solid, opaque object, whether you can actually see them or not.*

Three-dimensional. *The square at the top right has only two dimensions—height and width. To make objects seem three-dimensional, you must also draw in depth, as shown in the three-dimensional cube at the top left.*

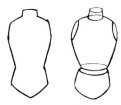

Construction vs. outlining. *An object that is "well constructed" has depth, as well as height and width. If the construction of your drawing is bad, you have merely outlined your forms, forgetting about depth, or you have made mistakes in the basic structural lines.*

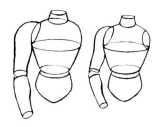

Proportions. *Each separate form in the drawing at the top left is properly proportioned, but the different forms are not properly "related" to each other. Make sure that the individual forms in your drawings have the right proportions and that when those forms are put together they have the proper relationship to each other, as in the drawing at the top right.*

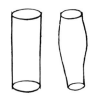

Modified cylinders. *The cylinder at the top left is a geometric object, perfectly regular in shape and proportions. The tapered cylinder next to it is essentially the same basic cylindrical form, but the shape has been modified slightly. This is what we call a "modified cylinder."*

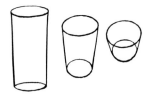

Foreshortening. *When an object is tipped toward you or away from you, it is said to be "foreshortened." It seems to diminish in size and change in shape as it recedes. In the case of the cylinder, notice that the sides become shorter and the ellipses more open as the foreshortening is increased.*

Dos and Don'ts

No matter how careful you are in drawing the figure, you will sometimes find that you have made mistakes in construction or proportions without realizing it. The drawings in this section show you the most common errors.

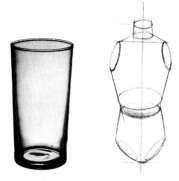

Remember to draw the figure through. Think of the individual forms as though they were drawn within transparent glass cylinders. Then you will be able to avoid making "outline" drawings without three-dimensional solidity.

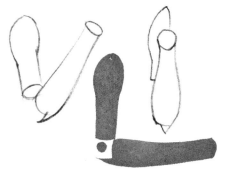

In these three drawings the lower part of the arm is much too long as compared with the upper part.

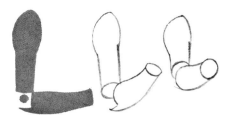

The three drawings above show you the right relationship between the upper and lower portions of the arm.

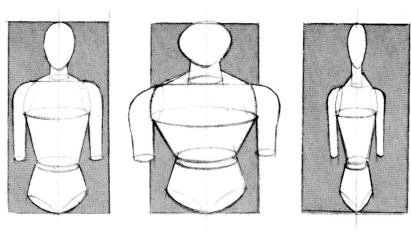

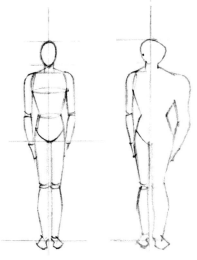

Don't get in the habit of making your figures too broad or too narrow. Remember that the head form you are using as a measuring unit must be correct in its proportions of height and width. Remember particularly that the three-head measurement for the upper body includes the shoulders.

The two sides of your figure should be alike in width *as well as in height. It is easy to check this in straight front or rear views; it is more difficult if the figure is drawn in a three-quarter view, which means it is foreshortened.*

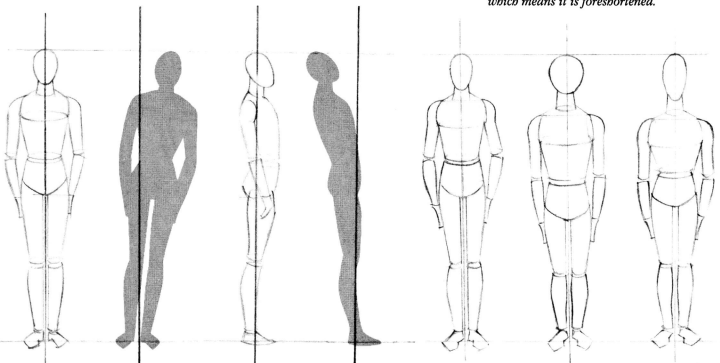

If you are drawing a vertical figure, like those above, establish a vertical axis and balance the figure on that axis.

The two drawings at the top right demonstrate what happens when the proportions of the individual parts of the body are incorrect. Notice the wrong head shapes, the long necks, the proportions of the torso as compared with the arms and legs.

Chapter Five
STRUCTURE

What gives the human figure its balance, flexibility and mobility is its design on an *S-curve*. The *S-curve* is constantly visible in the human figure. While a straight line is a rigid and fragile form, a curved shape is capable of flexibility and can manage the crucial task of self-balancing. The drawings here illustrate the profile, front and back views of bodies shifting weight and the way the *S-curve* controls and allows such actions. It begins at the top of the spine (base of the skull), follows the spine to the pelvis, then emerges at the front of the upper leg to the arch of the foot. The *S-shape* is also visible when people walk, sit, kneel, lie down, swim, dance, etc.

Muscles

The skeleton supports and is supported by the muscles. This interrelation creates a system of "tension" that is an arrangement of rigid and flexible parts. It is as if the skeleton is bound in a suit of rubber bands that work with and against each other, operating our bones, pulling them back and forth and up and down as we walk, run, move and breathe. The drawings in this chapter include illustrations of muscles joining bones at the elbow and shoulder, pulling them from their origin and causing operation of the bones where they insert. The "origin," in this terminology, is the static root of the muscle. It is the point from which the muscle pulls. The "insertion" is where action results. For example, when an arm is flexed, the biceps pulls the insertion, located on the forearm just above the inner elbow, towards its origin at the shoulder and causes movement of the forearm. When an arm is extended, the triceps pulls its insertion, located on the forearm just beyond the outer elbow, towards its origin, located behind and below the shoulder. When the triceps is flexed, the biceps is extended.

When the biceps is flexed, the triceps is extended. These muscles resemble rubber bands operating opposite each other to give the arm its power and movement.

There are approximately thirty-one points where the bones are visible under the skin. Examples are the elbows, ankles, wrists, knees, pelvis, collarbones, shoulder blades, knuckles, upper tip of the spine, bridge of the nose and the cheekbones. An artist must be aware of and capable of correctly indicating these points to give a feeling of the boniness of the human form. No matter the degree of fleshiness of a particular human figure, these points are almost always visible. This is particularly true at the joints.

The skeleton is operated by a system of muscles in varying degrees of tension. When opposing muscles are in equal tension, the body is still, as when standing erect. When the tensions are unequal, the body moves.

The skeleton forms the inner structure of the body. It is the framework or inner architecture of the human form. The bones that provide protection for the vital organs form container-like masses; the bones that enable bodily motion are long, rigid rods.

Basic Figure Drawing Techniques

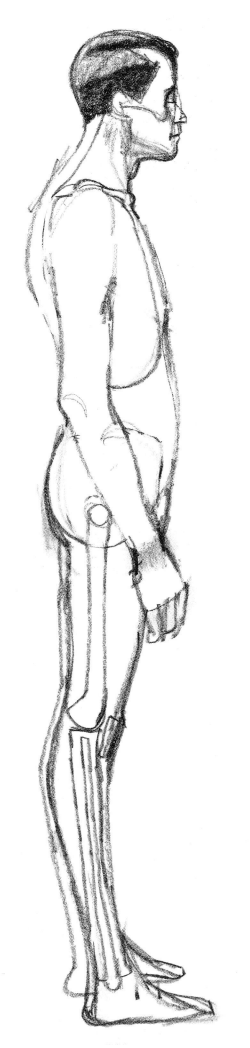
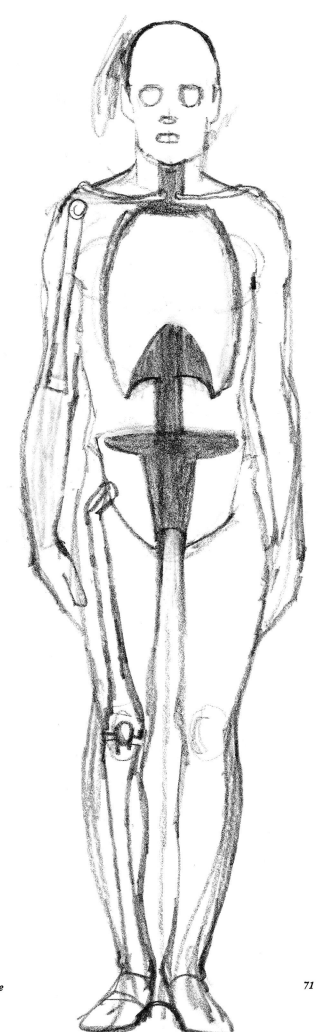

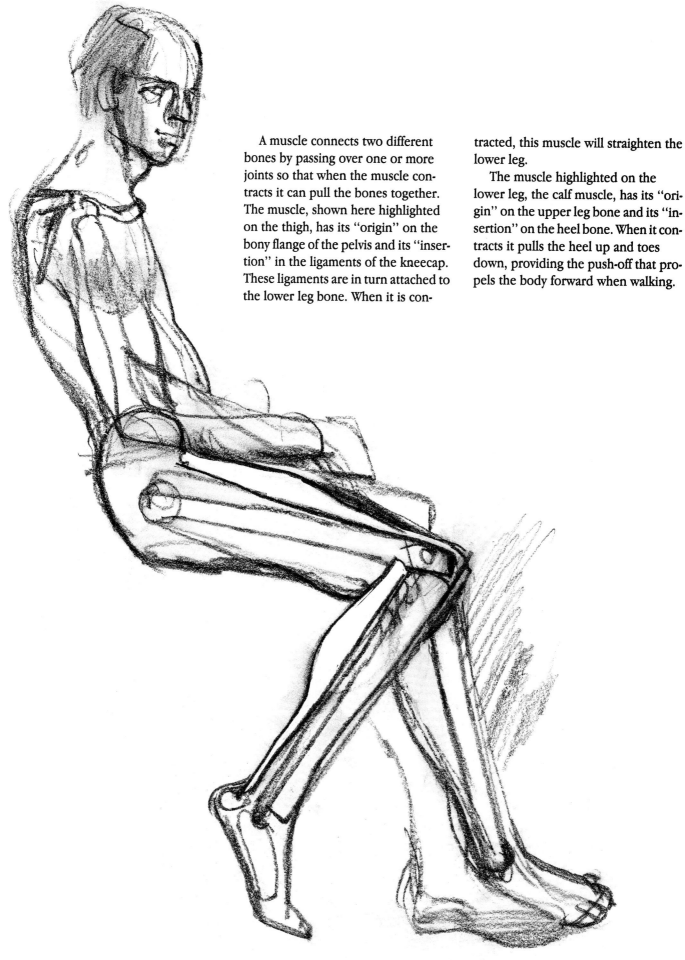

A muscle connects two different bones by passing over one or more joints so that when the muscle contracts it can pull the bones together. The muscle, shown here highlighted on the thigh, has its "origin" on the bony flange of the pelvis and its "insertion" in the ligaments of the kneecap. These ligaments are in turn attached to the lower leg bone. When it is con-tracted, this muscle will straighten the lower leg.

The muscle highlighted on the lower leg, the calf muscle, has its "origin" on the upper leg bone and its "insertion" on the heel bone. When it contracts it pulls the heel up and toes down, providing the push-off that propels the body forward when walking.

Basic Figure Drawing Techniques

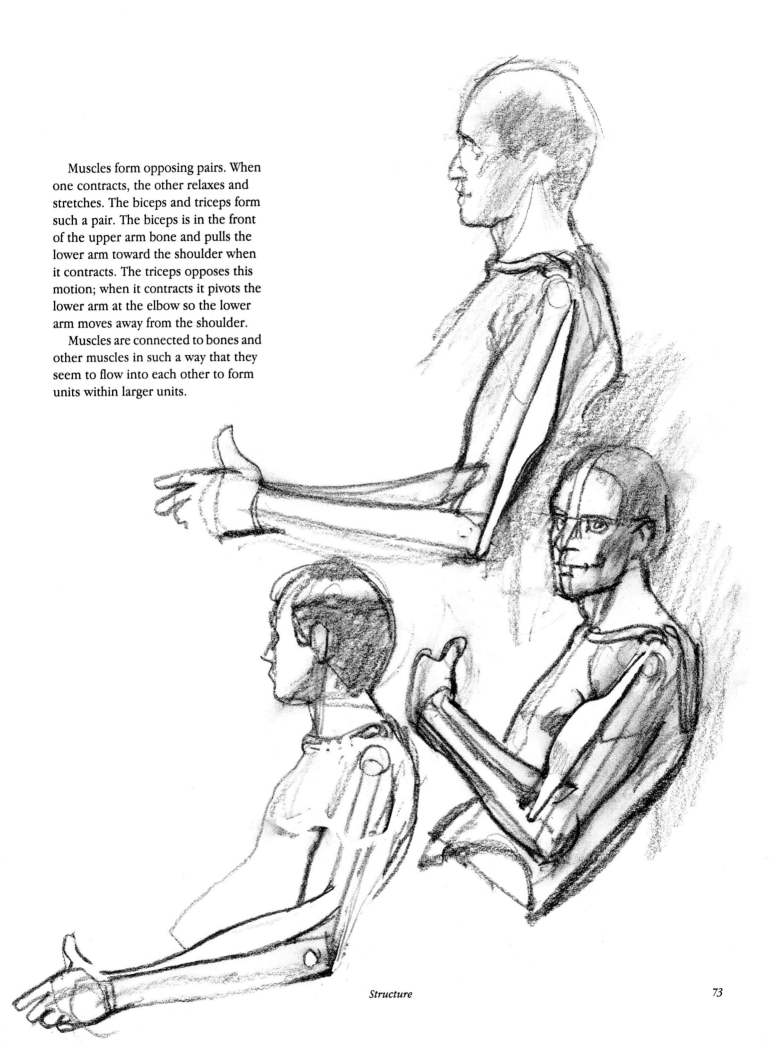

Muscles form opposing pairs. When one contracts, the other relaxes and stretches. The biceps and triceps form such a pair. The biceps is in the front of the upper arm bone and pulls the lower arm toward the shoulder when it contracts. The triceps opposes this motion; when it contracts it pivots the lower arm at the elbow so the lower arm moves away from the shoulder.

Muscles are connected to bones and other muscles in such a way that they seem to flow into each other to form units within larger units.

Structure

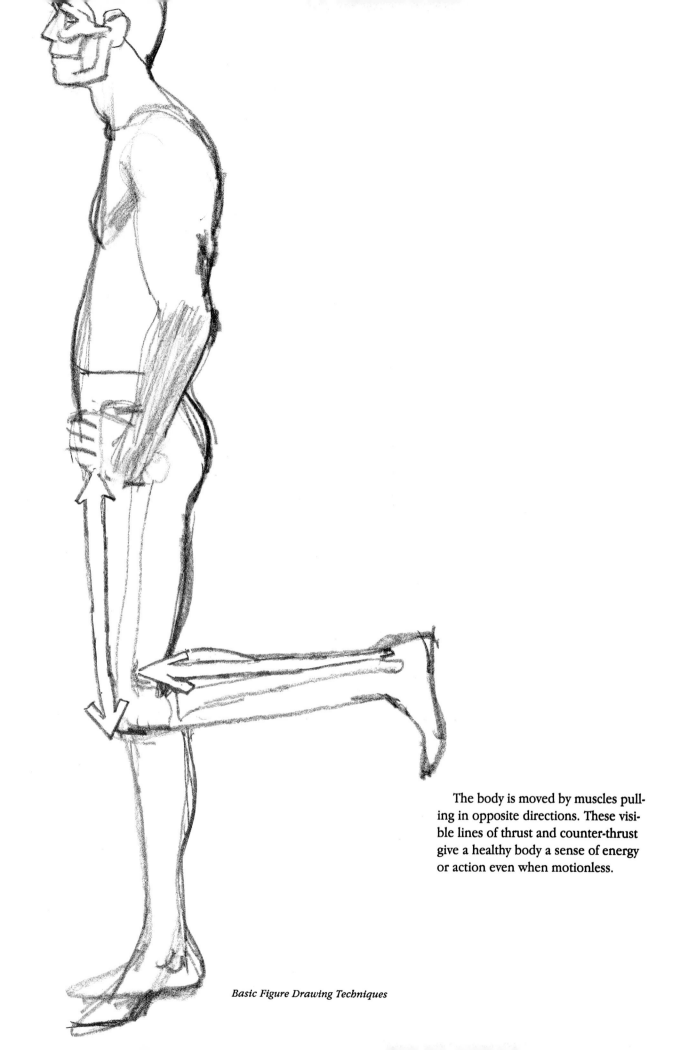

The body is moved by muscles pull-ing in opposite directions. These visi-ble lines of thrust and counter-thrust give a healthy body a sense of energy or action even when motionless.

Basic Figure Drawing Techniques

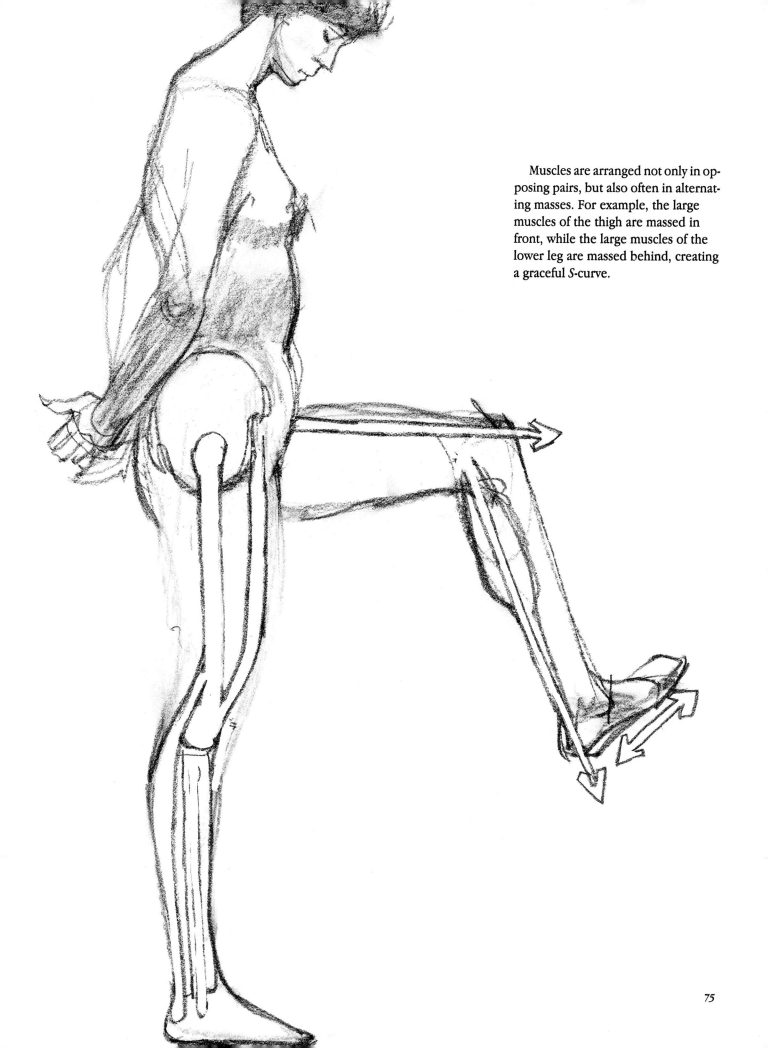

Muscles are arranged not only in opposing pairs, but also often in alternating masses. For example, the large muscles of the thigh are massed in front, while the large muscles of the lower leg are massed behind, creating a graceful *S*-curve.

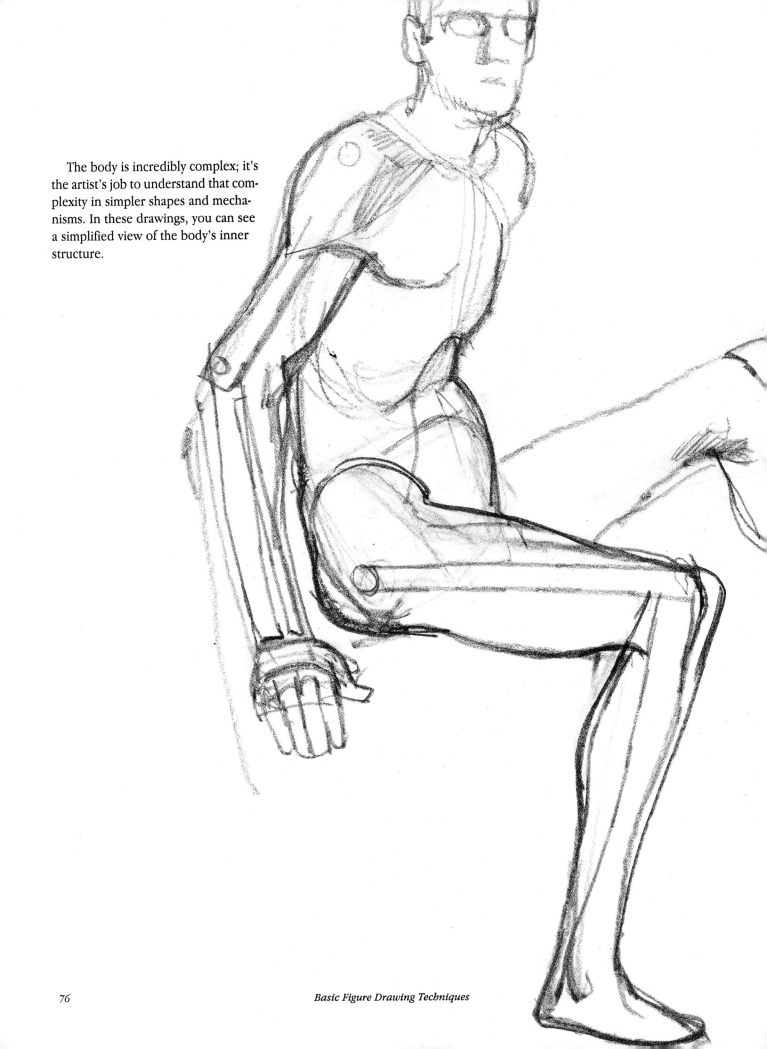

The body is incredibly complex; it's the artist's job to understand that complexity in simpler shapes and mechanisms. In these drawings, you can see a simplified view of the body's inner structure.

Basic Figure Drawing Techniques

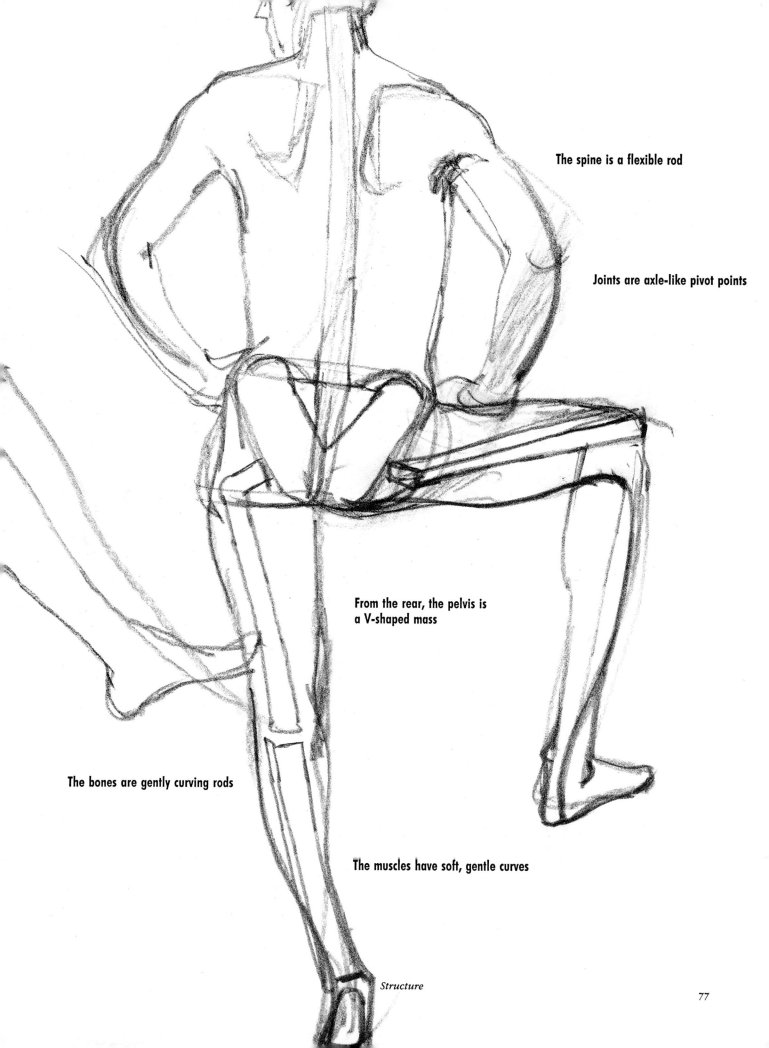

The spine is a flexible rod

Joints are axle-like pivot points

From the rear, the pelvis is a V-shaped mass

The bones are gently curving rods

The muscles have soft, gentle curves

Structure

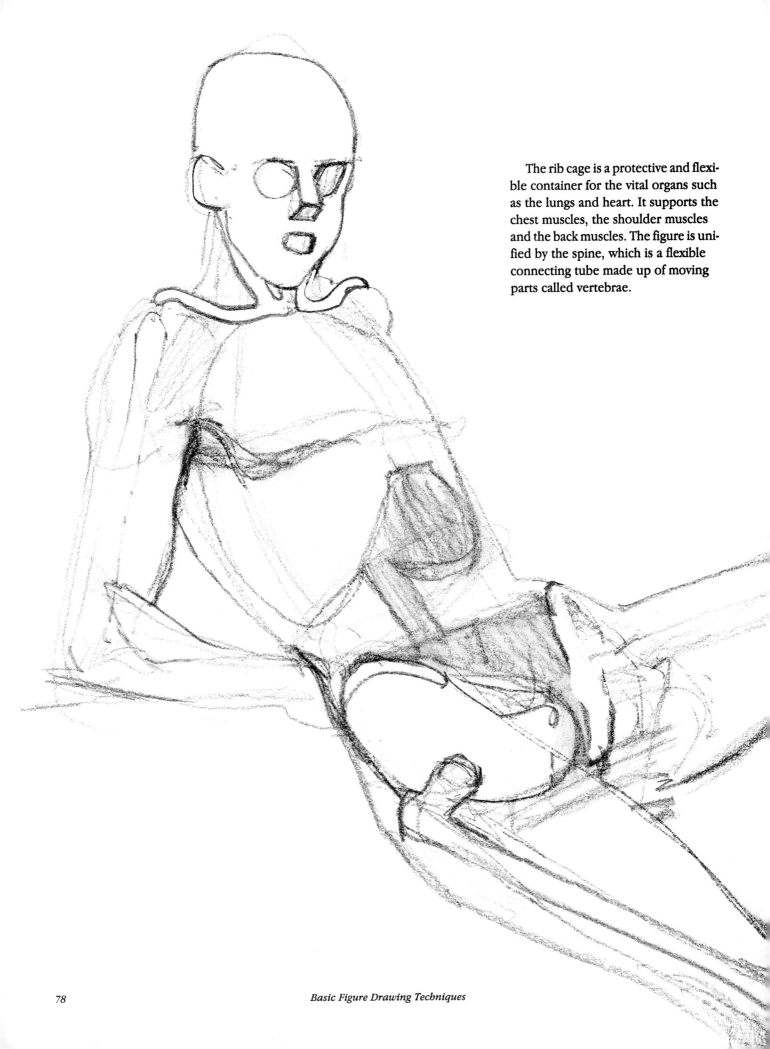

The rib cage is a protective and flexible container for the vital organs such as the lungs and heart. It supports the chest muscles, the shoulder muscles and the back muscles. The figure is unified by the spine, which is a flexible connecting tube made up of moving parts called vertebrae.

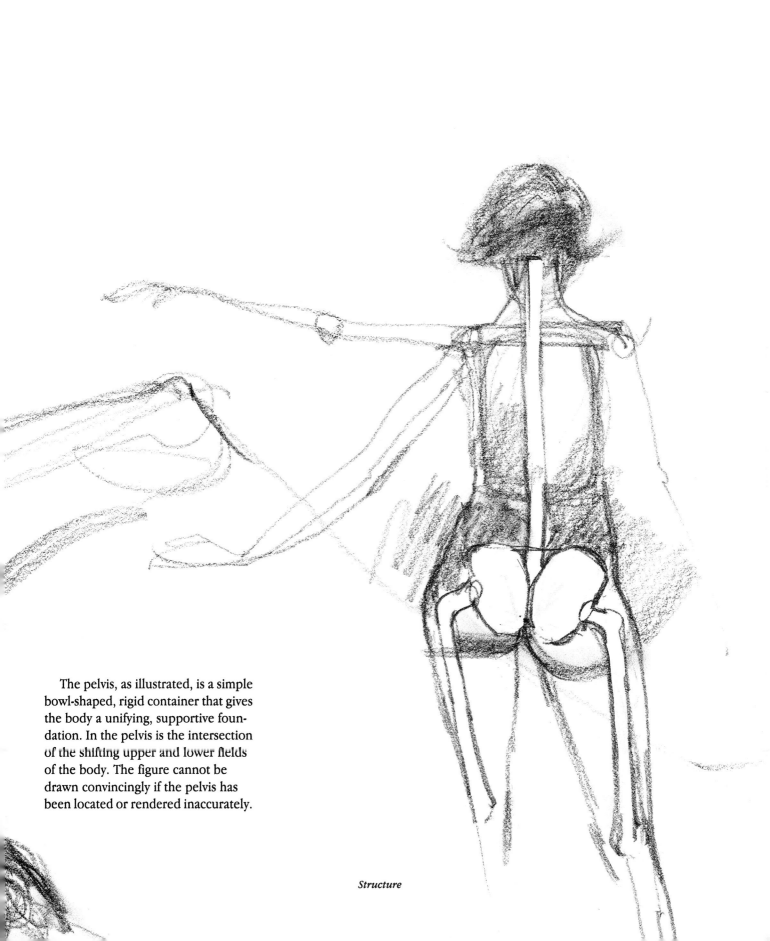

The pelvis, as illustrated, is a simple bowl-shaped, rigid container that gives the body a unifying, supportive foundation. In the pelvis is the intersection of the shifting upper and lower fields of the body. The figure cannot be drawn convincingly if the pelvis has been located or rendered inaccurately.

Structure

Joints

As discussed in the previous chapter, there are, for the artist's purposes, three categories of skeletal joints: ball-and-socket, hinge and irregular.

The ball-and-socket joints permit roughly 95 percent freedom of action. They provide adjacent limbs the ability to extend in a nearly complete 360-degree circle. The disadvantage of this range of motion is that these joints would be relatively unstable if they weren't surrounded by the largest muscles in the body.

The collarbone and the shoulder blade meet to form a cup-shaped socket at the top of the shoulder. Into this inserts the rounded end of the upper arm bone, completing a ball-and-socket joint. Covering this joint and keeping it in place is the deltoid muscle. In a similar manner, the rounded end of the upper leg bone inserts into the cup-shaped socket of the pelvis. It is supported in this position by the buttocks and a variety of lesser muscles.

The hinge joints such as the knee or elbow bend only in one direction and are less flexible but more rigid and stronger than the ball-and-socket joints. They lock into a rigid position and provide exceptional leverage. The arm is a lever with its power (insertion of the biceps) located between the fulcrum (the elbow) and the point of resistance (the hand). This provides us with an exceptional ability to pull objects in one direction—towards the body. The elbows allow movement only in two directions. They are highly specialized for activities such as pulling roots out of the ground and tearing fruit from branches. The legs, which also possess this highly specific ability to lock into position because of their hinge-type knee joints, guarantee balance and support as the body moves about. The need for stable joints explains why these limbs are hinged in this way at these locations.

Irregular joints are found in the wrist and ankle, where a number of small bones are located, allowing for the rather complex movements of the hand and foot.

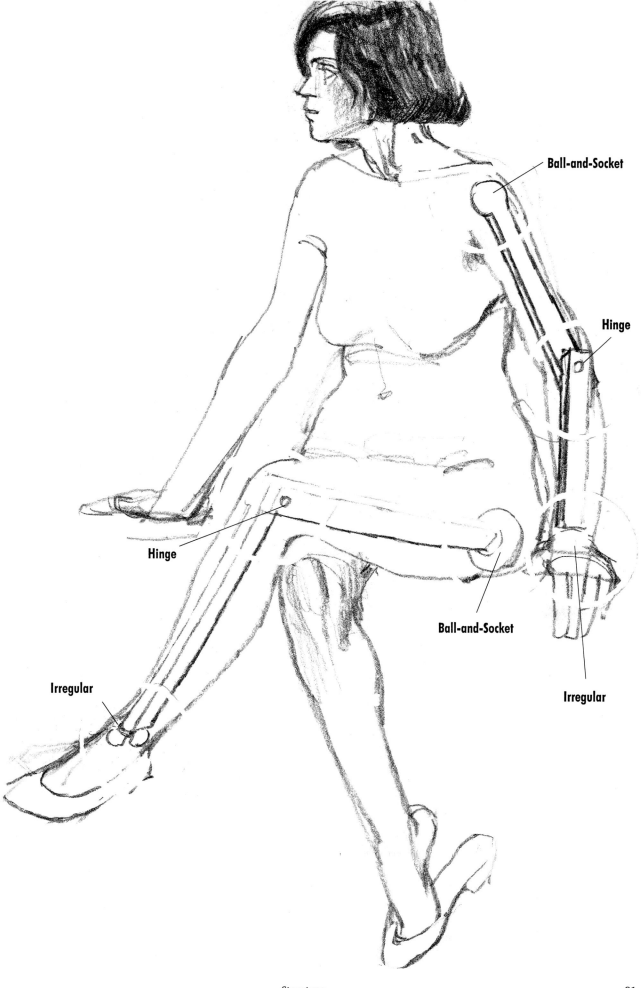

Ball-and-Socket

Hinge

Hinge

Ball-and-Socket

Irregular

Irregular

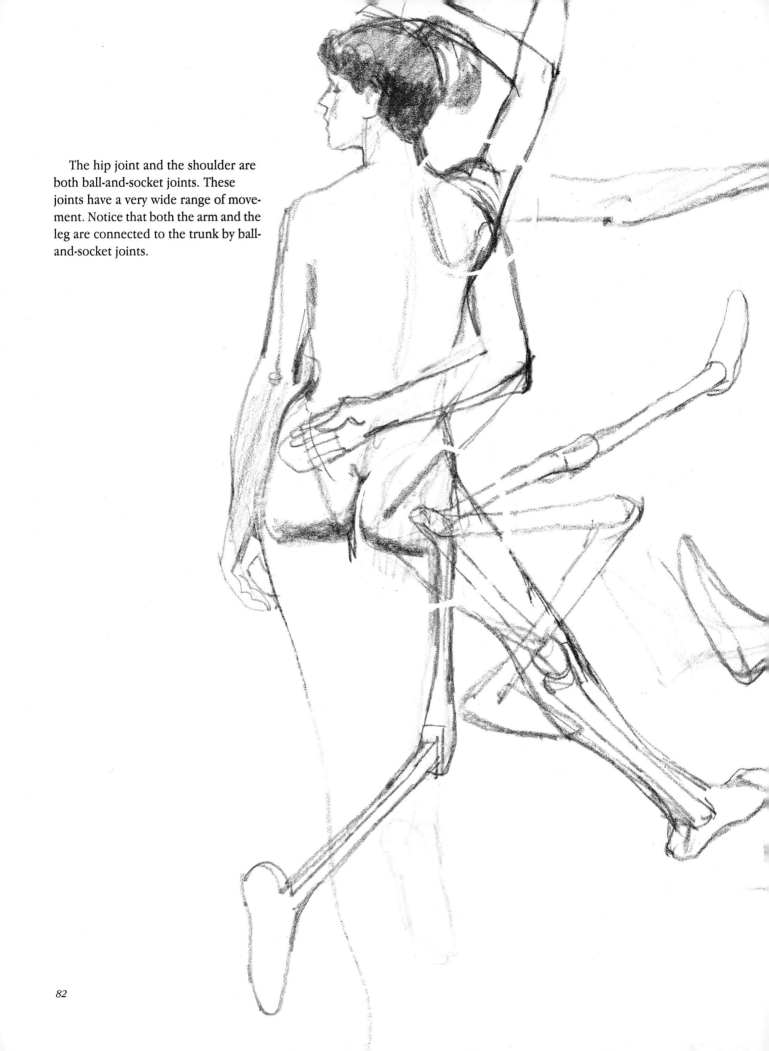

The hip joint and the shoulder are both ball-and-socket joints. These joints have a very wide range of movement. Notice that both the arm and the leg are connected to the trunk by ball-and-socket joints.

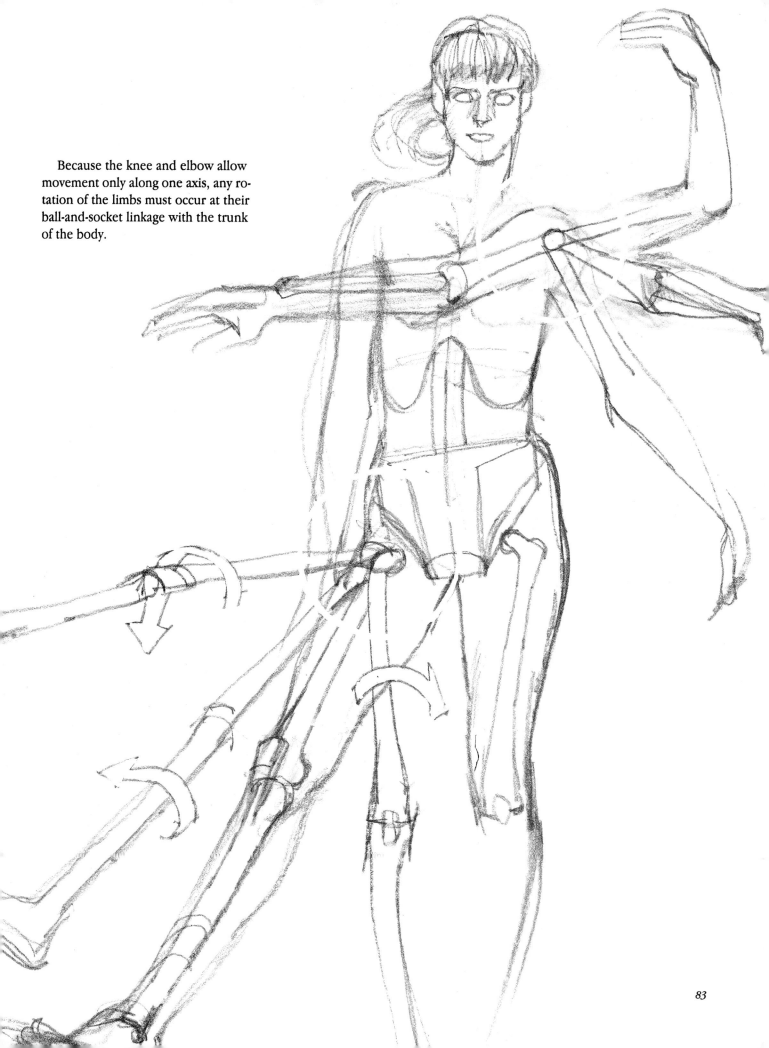

Because the knee and elbow allow movement only along one axis, any rotation of the limbs must occur at their ball-and-socket linkage with the trunk of the body.

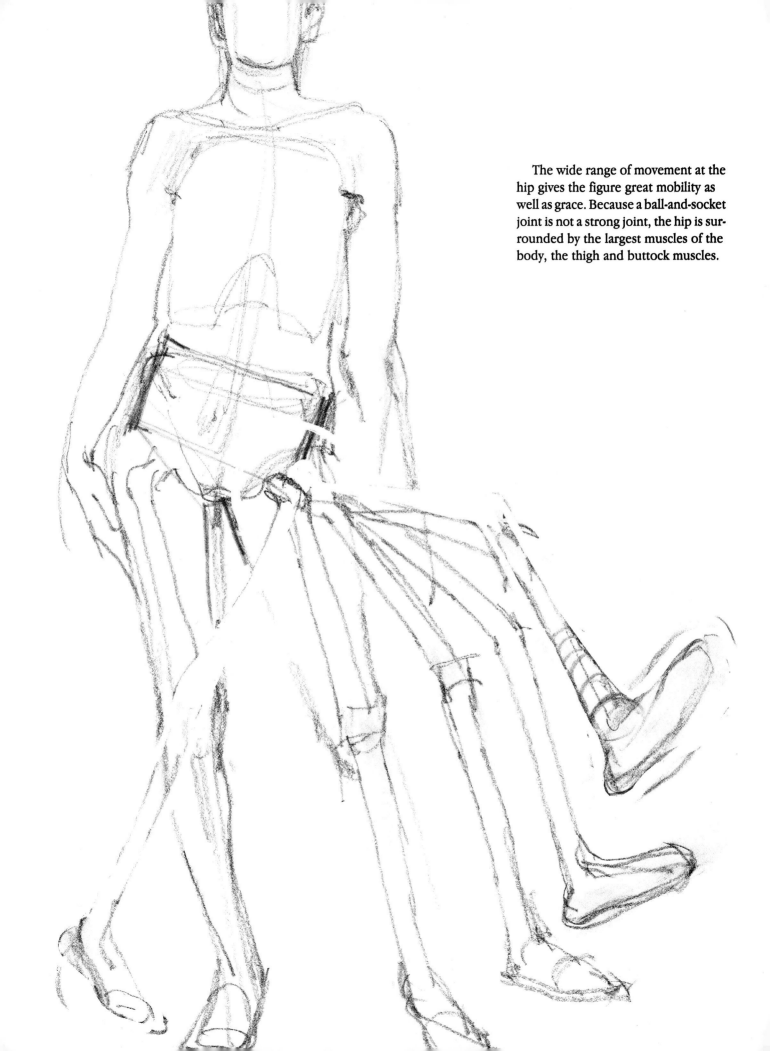

The wide range of movement at the hip gives the figure great mobility as well as grace. Because a ball-and-socket joint is not a strong joint, the hip is surrounded by the largest muscles of the body, the thigh and buttock muscles.

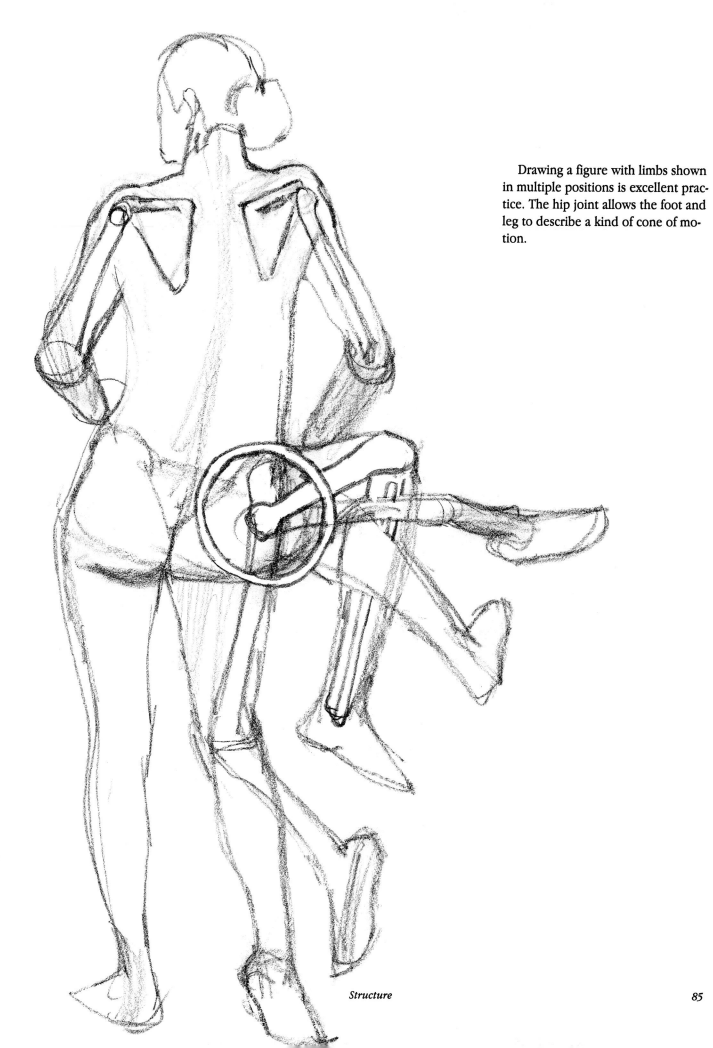

Drawing a figure with limbs shown in multiple positions is excellent practice. The hip joint allows the foot and leg to describe a kind of cone of motion.

Structure

Chapter Six
DETAILS OF THE FIGURE

In discussing the forms of the figure, we have to see what differences there are between male and female. Females usually carry more fat tissue than males, which covers the skeletal and muscular form and gives a soft, rounded look. The female is narrow in the shoulders and wide at the hips, just the opposite of the male. The bones of both skeletons are the same, but, with the exception of the hips, the female is smaller. Female facial features are finer and more delicate than the male's. The neck is more slender, appears longer, and doesn't have a distinct Adam's apple. The collarbone is more horizon-

tal, and muscle bulk is not evident in the chest and shoulders. The breasts sit on top of the chest muscles and vary in size and shape. In addition, the female waist is higher than the male's and the thighs and buttocks are heavier and smoother. The navel is below the waist and is deepset. The angle of the legs from the hips to the knee is greater in the female and gives her the tendency to appear knock-kneed, while the male tends to appear bowlegged. She has smaller hands and feet, and her body has less hair.

The male jaw is prominent and his nose angular and generous. His neck is

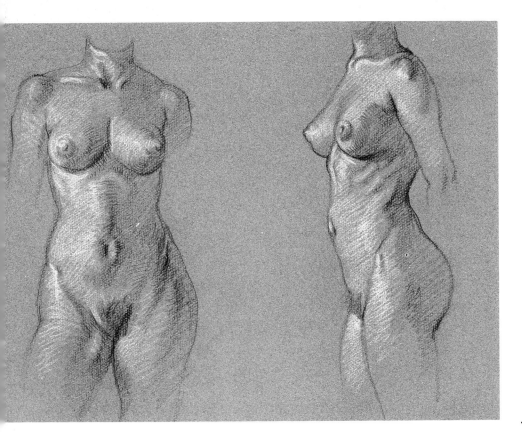

Far left: *The navel is deepset in the belly. The waist is high and the belly sits into the pelvic basin. The two front points on the pelvis project forward.*

Immediate left: *The ribs show under the breasts and have a downward slant from back to front.*

Basic Figure Drawing Techniques

thick and his shoulder muscles large, pulling the collar bones upward as they point out towards the shoulder tips. All of this gives his neck a shorter look than the female's. His feet and hands are larger in proportion to his body. He may have a noticeable beard, as well as a thin coat of body hair that becomes dense on his chest, pubic area and under his arms.

The male skeleton is larger, and the muscles more developed than the female's. Also, the male figure carries less body fat, which gives him a more angular look. His shoulders are wide and his hips narrow.

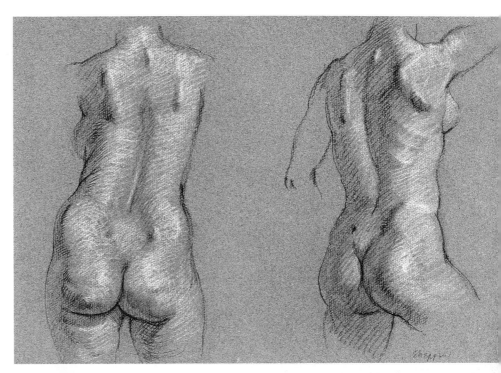

Top left: *The muscles and fat of the buttocks create a butterfly shape (see diagram below). At the base of the spine, between the two cheeks, there is a triangular shape formed by two dimples and the crease between the buttocks.*

Top right: *The shoulder bones show on the surface and move with the arm. At the base of the neck the vertebrae are visible.*

Triangle

Butterfly Wings

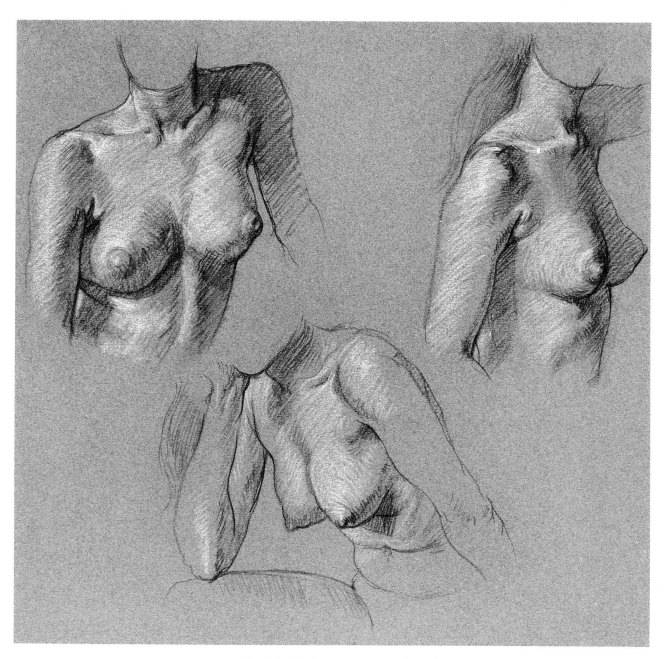

Top left: *The breasts are wider than they are high. The nipples point outward from the middle and slightly upward (see diagrams below). The neck is a cylindrical shape that fits into the torso behind the collarbones.*

Center: *The breasts attach loosely to the underlying chest muscles. The chest muscles extend into the arm, forming the front wall of the armpit.*

Top right: *Fat extending behind the breast toward the armpit creates a comma shape (see diagram at left). The top outline of the breast is a long, slow curve to the nipple. The bottom outline is a short, sharp curve.*

Cross Section

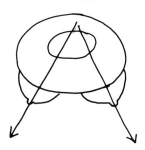

Direction of Nipples

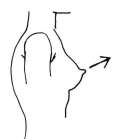

Comma Shape

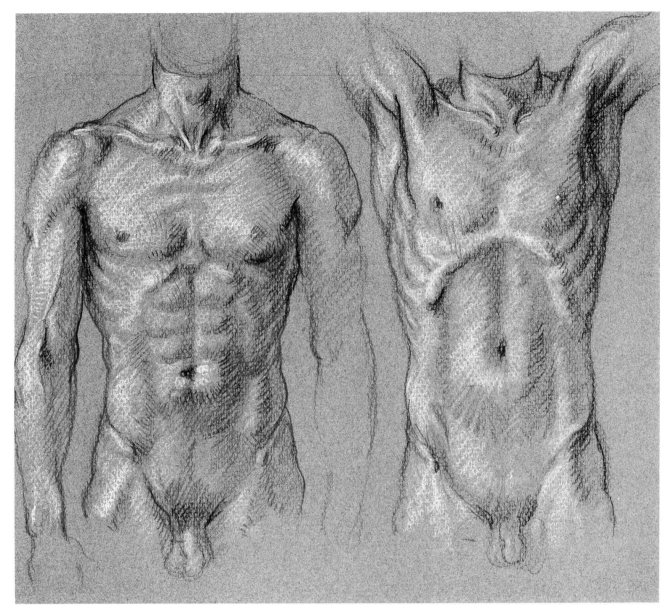

Left: *The collarbones angle upward away from the base of the neck. The ribs attach to the breastbone or sternum. The rib cage and pelvic basin form a violin shape (see diagrams below).*

Right: *The chest muscles flatten and stretch up into the arms. The ribs start high in the back and extend downward toward the front. The rib cage becomes prominent when the arms are raised.*

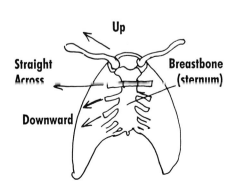

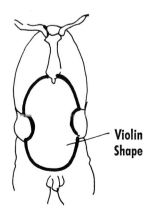

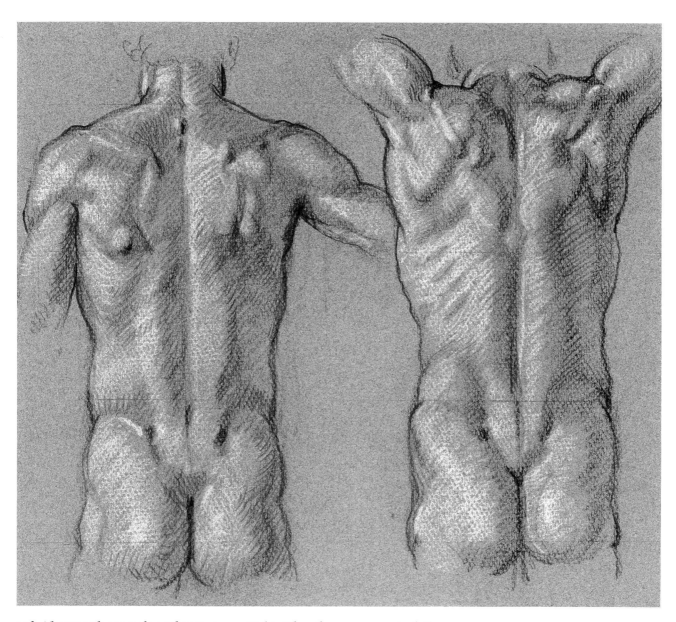

Left: *The seventh cervical vertebra is visible on the back of the neck. The shoulder blades are prominent, and two dimples are formed by the pelvic crests. A flat triangle is formed by the two dimples and the crease in the buttocks.*

Right: *When the arms are raised, the angle of the shoulder blades follows the arms.*

Basic Figure Drawing Techniques

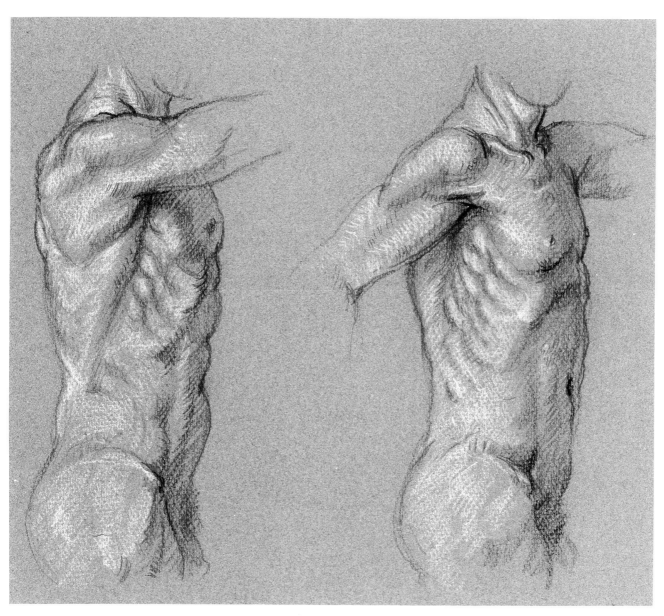

Left: *Small, fingerlike muscles attach to the ribs on the side of the rib cage, making a break in the line of their downward slant (see diagram at right). When the arm is raised forward, it's obvious that the muscles of the back extend into the arm.*

Right: *When the arm is pulled back, the chest muscle forming the front wall of the armpit extends out into the arm.*

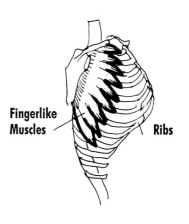

Fingerlike Muscles

Ribs

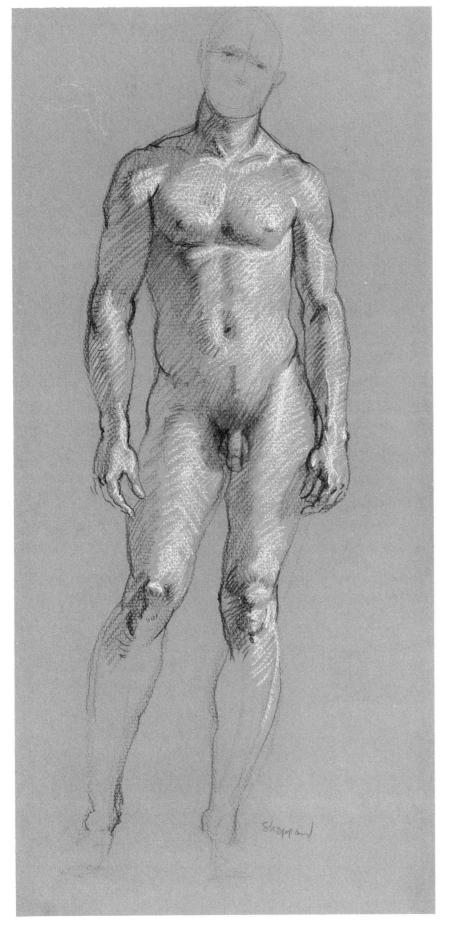

Key Shapes

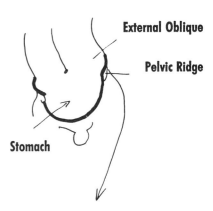

The model's weight is on his left leg and his shoulders and hips are at opposite angles to provide balance. The external oblique muscles overlap the pelvic ridge, and the stomach fits down into the basin of the pelvis (see diagram above).

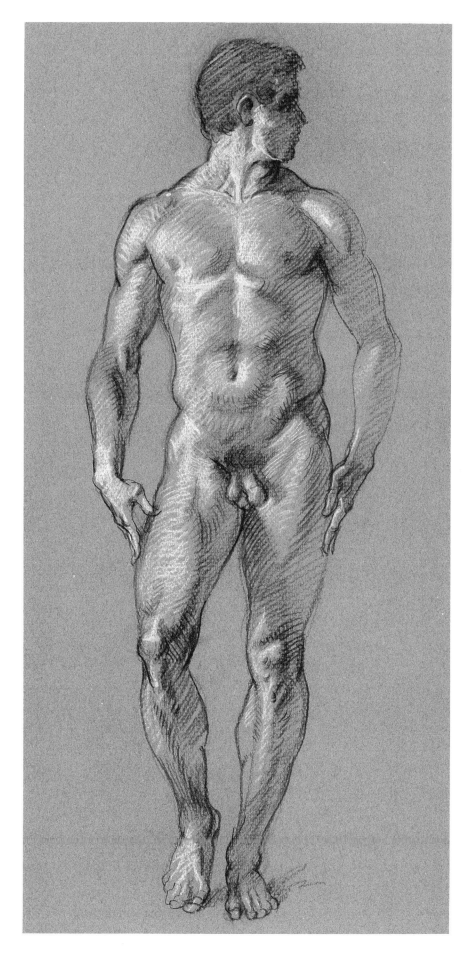

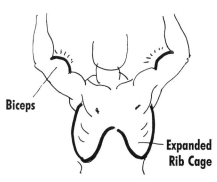

Biceps

Expanded Rib Cage

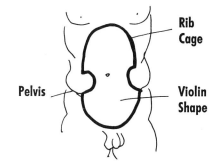

Rib Cage

Pelvis

Violin Shape

Again, a large violin shape is created on the front of the torso by the hollow of the rib cage and the ridge of the pelvis. The inside of the ankle is higher than the outside and at the knee the outside of the lower leg is higher than the inside (see diagrams above).

Details of the Leg

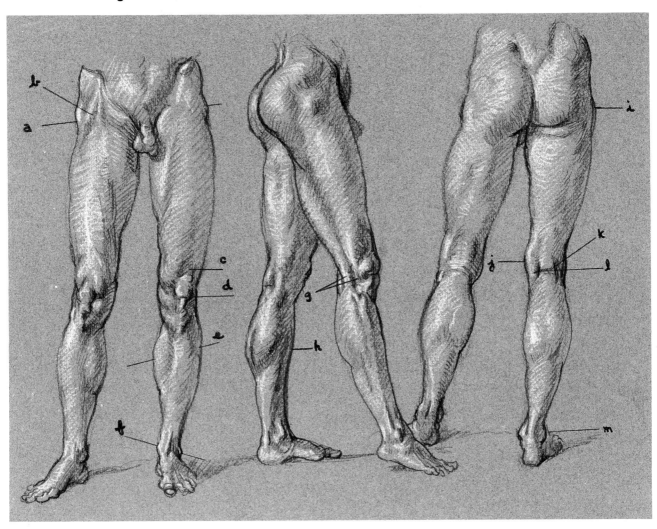

Left: *Angle* **a** *is the midpoint of the body and goes from one hipbone through the pubic area to the other hipbone. Muscles attached to the pelvis create an upside-down V shape* **b**. *The locked knee creates a depression above the kneecap* **c**. *The kneecap is rounded and its bottom is the sixth head measurement* **d**. *The outside of the calf is higher than the inside* **e**. *The angle* **f** *of the ankle runs the opposite way, with the inside of the ankle high and the outside low.*

Center: *Two strap-like tendons from the upper leg attach to the top of the lower leg on the outside of the knee* **g**. *The front of the shin has a slight S shape* **h**.

Right: *The hipbone protrudes on male figures* **i**. *The inside of the knee has a sharp angle to it* **j**. *The tendons on the back of the knee and the folding crease form the letter H* **k**. *The midpoint of the leg* **l** *is the sixth head measurement. The ankle is the eighth head measurement and the inside is higher than the outside* **m**.

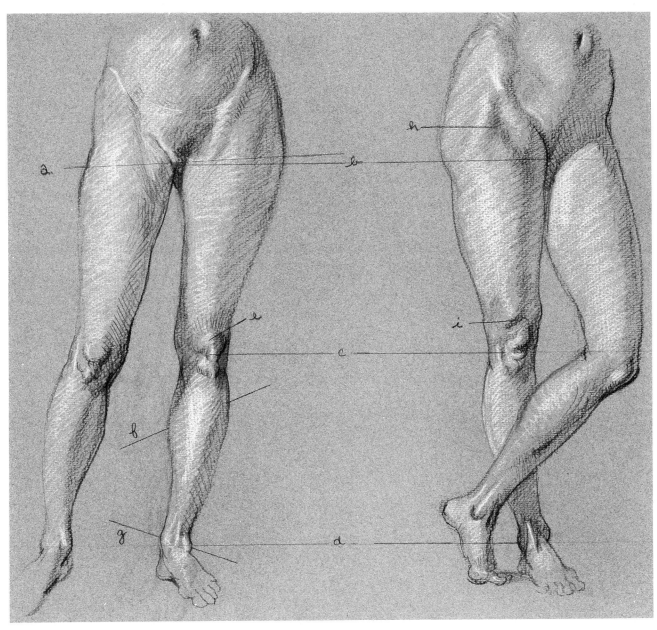

Above left: *Angle* **a** *is the midpoint of the body. The kneecap is a round shape that rests on line* **c**, *which is the midpoint between the hipbone* **b** *and the ankle* **d**. *Beneath the kneecap is another round, fatty shape* **e**. *The outside of the calf is higher than the inside, making angle* **f**. *The inside of the ankle is higher than the outside, forming the opposite angle,* **g**. *Starting with the hipbone, a muscle runs obliquely across the leg down to the inside of the knee. A spiral line is formed by continuing down the shinbone of the lower part of the leg to the inside of the ankle (see diagram at right).*

Above right: *When the leg is tensed, muscles attached to the pelvis make an upside-down V shape* **h**. *The locked knee also causes a depression above the kneecaps* **i**. *The inside of the ankle is farther forward than the outside.*

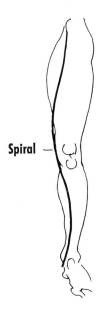

Spiral

Details of the Arm

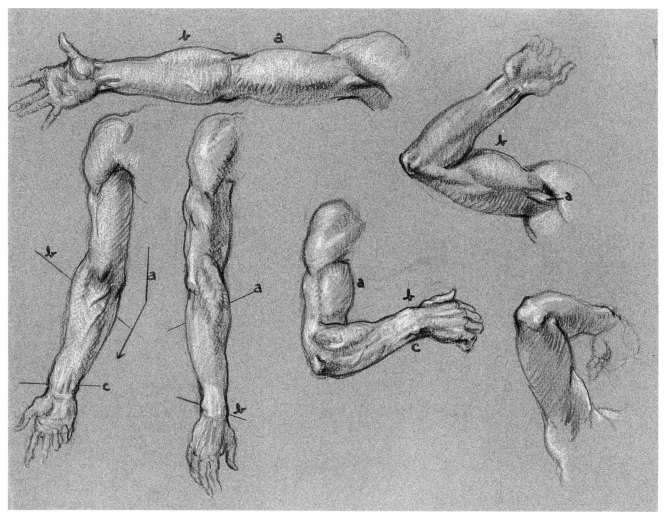

Top left: *The biceps of the arm a emerges from underneath the shoulder muscles. The top of the forearm makes a high silhouette b.*

Center left: *When the palm is turned in, the arm straightens and the two angles of the forearm a and wrist exchange direction b.*

Center: *When the arm is bent, the biceps a swells and the bones of the elbow protrude. The bone on the thumb side of the wrist b is longer than the bone on the little finger side c.*

Top right: *There is a small muscle a in the armpit that is exposed only when the arm is raised. The biceps b swells as it raises the arm.*

Lower right: *When the elbow is bent, the bones of the elbow form a triangle (see diagram).*

Lower left: *When the palm of the hand is forward, the forearm angles away from the body a. The outside of the forearm is attached high above the elbow and creates an angle with the inside b that is opposite the angle of the bones at the wrist c.*

Three prominent bones make a triangle

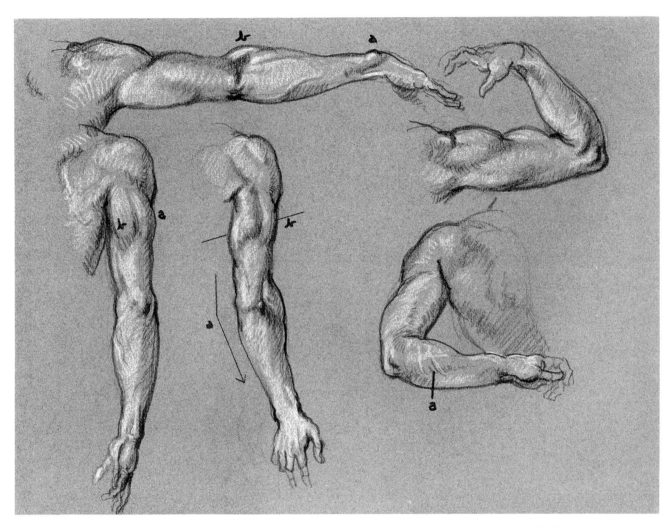

Top left: *The wristbone on the little finger side is very prominent* **a**. *There are two muscles on the top part of the forearm that create the high silhouette* **b**.

Lower left: *When the palm is turned in, the arm hangs straight. The muscle on the outside of the upper arm* **a** *is more prominent and shorter than the one on the inside* **b**.

Center: *The lower part of the arm angles out away from the body* **a** *when the palm faces forward. The outside of the upper arm is higher than the inside* **b**.

Top right: *The back muscles extend into the arm. The biceps bulges when it raises the arm.*

Lower right: *The arm is bent behind the torso. The bones of the elbow protrude, and a shadow* **a** *on the forearm indicates the direction of the bone.*

Details of the Hand

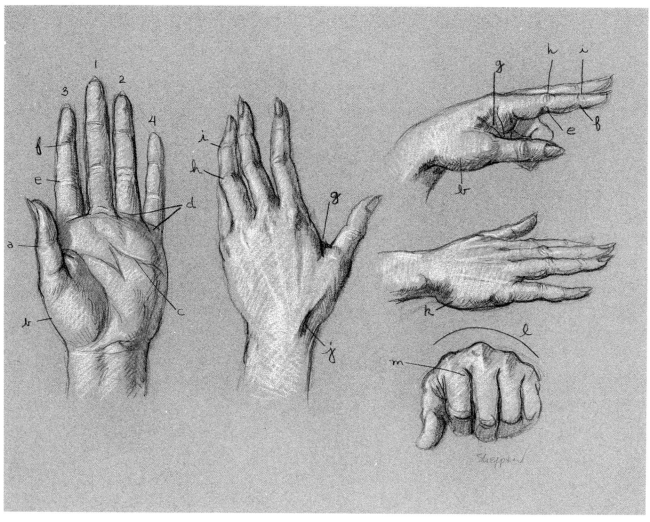

Left: *The palm view of the female hand. The thumb* **a** *has only two joints; the other fingers have three. The ball of the thumb* **b** *sits separate from the rest of the hand. Folds in the palm* **c** *create the letter M. The fingers are numbered here in order of their length. Folds* **d** *are created on the palm where the fingers bend: The two middle fingers have two folds; the little finger and the index finger have one fold. Joint* **e** *has two folds and joint* **f** *has one fold.*

Center: *The back of the hand. Knuckle* **i** *has smooth creases and knuckle* **h** *has fleshy folds of skin. The muscle that pulls the thumb across the hand* **g** *is attached on the palm side.*

Top right: *The thumb side of the hand.*

Middle right: *The little finger side of the hand. The muscles form a long pad on the little finger side* **k**.

Bottom right: *The fist. An arch is formed* **l** *when the hand is made into a fist; the middle finger knuckle is the highest point. The creases from the middle finger point outward* **m**.

Basic Figure Drawing Techniques

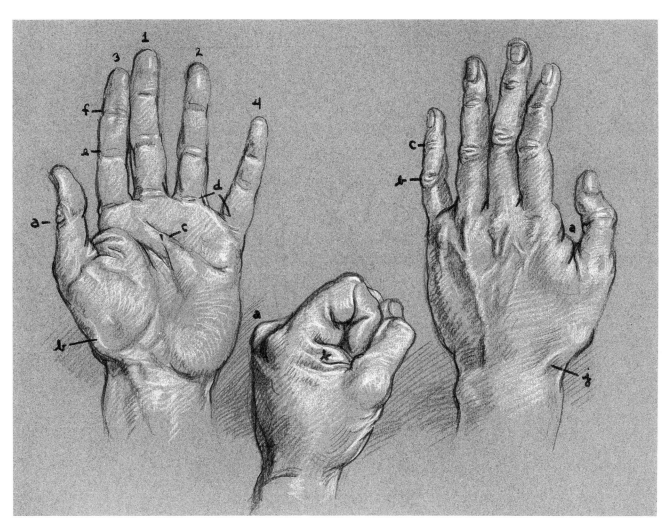

Left: *The palm view of the male hand. The male hand is not as graceful or soft as the female's. The male hand looks more square, while the female hand appears longer and more narrow. The thumb **a** has only two joints. The ball of the thumb **b** is separate from the rest of the hand. Folds in the palm **c** create the letter M. The fingers are numbered here in order of their length. Folds **d** are created on the palm where the fingers bend: The two middle fingers have two folds; the little finger and the index finger have one fold. The second joint **e** has two folds and the upper joint **f** has one fold.*

Center: *The middle knuckle **a** is longest. Folds are created from the muscles **b** that draw the thumb across the hand.*

Right: *The back of the hand. Knuckle **c** has smooth creases and knuckle **b** has fleshy folds of skin. The muscle that pulls the thumb across the hand **a** is attached on the palm side. There is a small triangular depression, caused by tendons to the thumb, called the "snuff box" **j**.*

Chapter Seven
THE HEAD

Two aspects of the human figure are most important in revealing individuality and character: the head and the hands. First, let's discuss drawing the head.

Almost invariably if you think of someone, you think of their face first. The face identifies and sets apart every individual on earth. Our faces are as much a part of our personalities as our emotions, our thoughts, our likes and our dislikes. These characteristics show plainly to others, whether we think so or not.

The primary importance of the head is apparent. Important functions involved with the business of living begin here—the senses of seeing, hearing, tasting, and the sense of smell. The head is also the storehouse of the brain, which, of course, controls the voluntary actions in the human body.

While all faces have a great deal in common, it is easy to place them in different categories: the broad, the lean, the round, the flat, the strong, the weak, the ugly and the beautiful.

In most pictures the head and face are the focal point of all attention and its attitude and expression are the quickest means of communication. In picture making, the face expresses human relationships—bridging the gap between the subject who has been painted and the person who views the picture.

The eyes are the most expressive feature of the face. They can tell more vividly than words our emotions and moods, even against the will of the subject who does not wish to show his or her feelings.

By subtle shifts in position, the eyebrows, along the upper crest of the eye socket, play a vital role in complementing the expression of the eyes and the other features in indicating the subject's mood.

Although the nose is stationary except for the slight capability for movement in the cartilage of the nostrils, it can be used very successfully to help portray and develop many human characteristics and types.

The ear is deceptively complex. It requires a considerable amount of study and practice to draw it properly. The shape of the ear varies mostly at the top and the bottom. At the top it may look like a high or shallow arch and the turning of the rim may be broad or narrow. The bottom of the ear forms a lobe, or it may simply join the neck without one. The ear has often been compared to a seashell due to its whorls and convolutions.

Next to the eyes, the most expressive feature of the face is the mouth. In repose its normal shape can be most easily studied. The mouth in movement can denote many emotions. The lips, turned slightly upwards at the outer ends, may show good humor—when turned down they denote unhap-piness or melancholy. They can denote determination or frustration, or they can, without words, signify the desire to be kissed or show distaste. Both narrow and broad mouths can be beautiful, depending on their proportions to the rest of the face. The shape of the mouth may also decidedly show character in both men and women. The broad mouth usually denotes generosity and friendliness—the thin mouth, pettiness of nature. These assumptions are not always true, but in making pictures, they do indicate character.

The chin can have a marked effect upon the character of the face. When it juts forward and is pronounced, it can give a feeling of aggressiveness and determination. When it recedes, it can denote a lack of strength. When drawing a woman, a rounded chin is more desirable. A prominent jaw line is more acceptable in a man than in a woman.

Finally, consider the head and hands in relation to each other. Stand in front of a mirror—look at yourself. Then frown, then smile, cry, laugh, look mean, look happy, look sly, look sick. Try to act these emotions out— and feel what is happening to your hands. You find that your hands unconsciously go through the same emotions. You cannot, for example, get really mad without clenching your fists, or feel completely relaxed without your hands also relaxing.

Front View

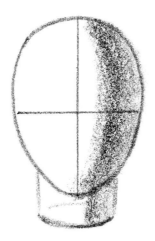

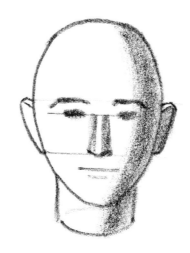

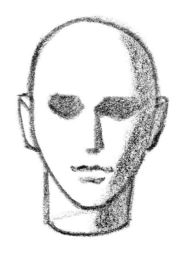

Step 1.

The head is an egg-shaped sphere with the narrow end at the bottom. It rests securely on the neck, which is a short cylinder. The horizontal and vertical center lines are guide lines for placing the features.

Step 2.

The eyes are located on the horizontal center line, the eyebrows on another line a little higher. The nose extends from this line halfway to the chin. The tops of the ears line up with the brows, the bottoms with the base of the nose.

Step 3.

The eyes are recessed under the brows. The nose is a wedge shape with planes. The egg shape is modified so it has side planes too.

Side View

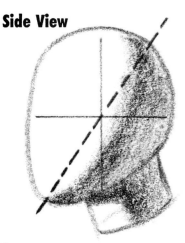

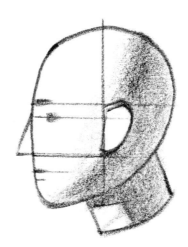

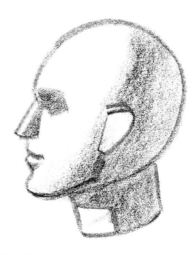

Step 1.

The form is wider at the top and narrower at the bottom than in the front view. Note that the egg shape is tilted, as shown by the diagonal line. The neck is toward the back of the head and slants forward.

Step 2.

Nose and eyebrows are located as described at the left. The ear is placed just back of the center of the head. The top is level with the brow, the bottom with the base of the nose. Two lines indicate the mouth—one suggests the mouth opening, the other the bottom of the lower lip.

Step 3.

The jaw line angles down from the ear. The nose and ears are solid forms.

Blocking in the Head

In blocking in the head and planes of the face, let us begin by observing the proportions of the head. To divide the oval head and place all the features in their proper relationship to one another, we first divide the head into four equal parts—from the top of the head to the hairline is one-quarter the distance, the forehead is the next quarter, from the eyes to the nostrils is the next quarter, and for the last quarter we go to the point of the chin. Next draw a line down the center of the head from the top to the bottom.

We now place the eyes on the vertical center line on each side of the nose. The distance between the eyes should be the length of one eye. The length of the ear is about the same as the nose and is on a line with it. When the head is seen in profile, the ear is just above the middle of the neck. The bottom of the lower lip is halfway between bottom of the nose and the chin. The top of the nose starts at the upper lid of the eye. The width of the nose at the nostrils is the width of one eye. When the nose is seen in profile, the distance from its tip to where the nostril unites with the cheek is also about the length of one eye. The distance from the chin to the throat is equal to the space between the mouth and the bottom of the chin.

"Blocking in," whether it be features, planes and forms, or to establish attitudes, should always be done sketchily and lightly so that when you are ready to draw the finished result, the blocking in lines can be easily erased.

Exercise in Drawing the Head

It can be a useful—and illuminating—exercise to try out your first attempts at blocking in a head by selecting an eye-level photograph to use as a guide as shown below. Even a newspaper photograph will serve the purpose. Simply place the photo under a piece of tracing paper and draw the outer shape of the skull, then block in the proportional lines over the photo.

You may be somewhat surprised to realize how well virtually every head (barring any photographic distortion) will fit these measurements and how minor and subtle are the facial characteristics that serve to identify each person as an individual.

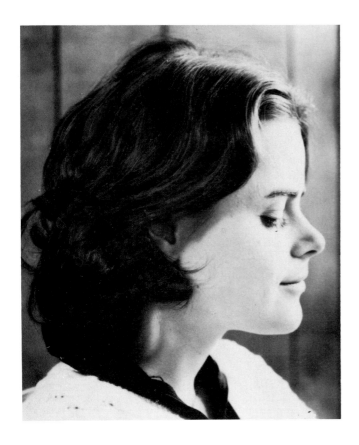

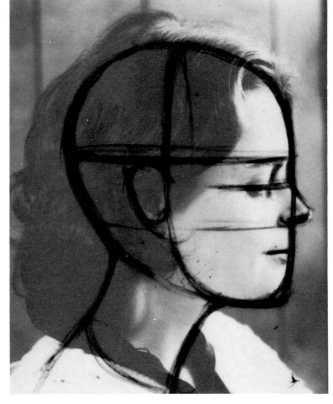

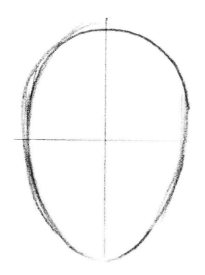

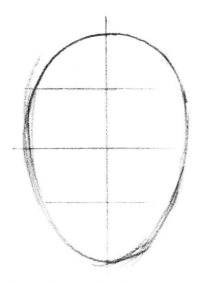

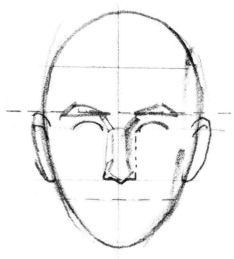

Sketch an egg-shaped oval divided into halves both vertically and horizontally.

The two horizontal halves are again divided in half, providing four equal segments of the head.

The eyes are located on the center line, the brows a quarter of the distance above the eyes. The mouth is one-third the distance below the nose to the chin.

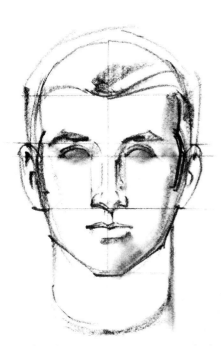

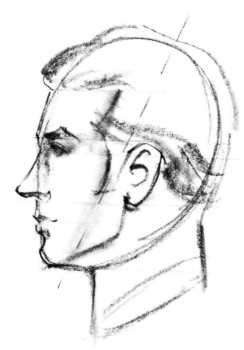

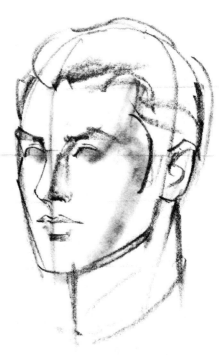

The hairline occupies approximately the top quarter of the head at the brow.

In profile, the oval is tilted and the ear is placed behind the center line as is shown. The features are located on the same parallel lines.

As the head is turned, the features can be located by the same divisional lines. The line in front of the ear also establishes the line of the jaw.

The Head in Different Positions

We have shown how to block in the head and locate the features in a few simple views. Actually, a head is hardly ever seen in these "straight-on" views. It is usually tilted to one side or the other; it may be looking up or down or be turned in a different direction from the body. If you're drawing the head in a tilted position it will not be possible to measure off the locations of the features the same way we did in the straight views. We will have to rely on our eye to tell us if the head is correctly drawn. The drawings on these two pages show why this is so.

In the drawings, the first thing you will notice is that the "measuring lines" become curves or ellipses as they run around the solid form of the head. A good way to study how tilting affects these lines is to draw a simple set of guide lines and features on the shell of an egg, as we demonstrate at the top of the page. By studying what happens to these guide lines as the egg is tilted and by making many sketches similar to those at the bottom of the page, you will learn to estimate the placement and direction of these various lines correctly. As you work, remember to draw through, carry your construction lines entirely around the shapes so you will understand what happens on the far side of the form as well as on the side you can see. In this way you can relate the various features and planes of the head correctly.

You will notice on the drawings below that a line runs down the middle of each face. This line will help you place the features in the correct position and at the same angle as the head. It also establishes the proper depth of the nose and underpart of the chin. In actual practice it is not always necessary to draw this line, but you should at least imagine it.

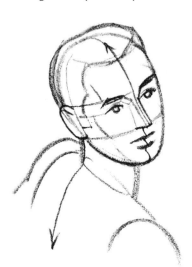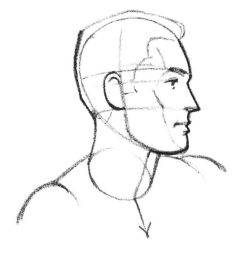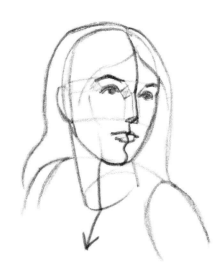

Guidelines drawn through to the other side become ellipses as the head tilts. Think of how a center line would follow the surface of the forehead, nose, lips and chin.

Front view, below and center. *As the head is viewed from above or below eye level, the horizontal measuring lines become curved or elliptical in shape. The divisions are no longer equal.*

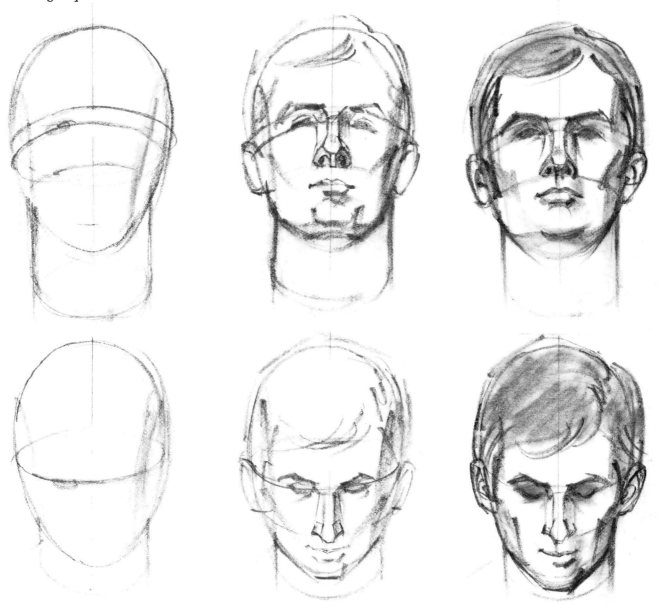

Three-quarter view, below. *Here the vertical center line is no longer straight, but goes in and out as the shapes of the features dictate.*

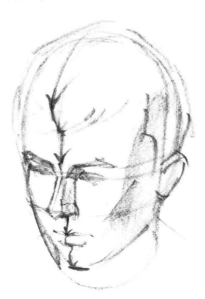
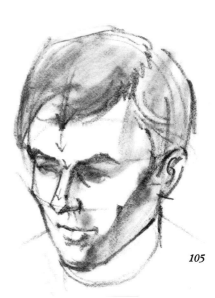

Helpful Reminders for Drawing the Head

Here we show you how to solve some common problems when drawing the head. In each case the solution lies in:

- Deciding which way the head and features are tilted
- Thinking of the features as solid, related forms
- Drawing through

Notice that as the head turns away, some features overlap or hide others from view, while some disappear completely.

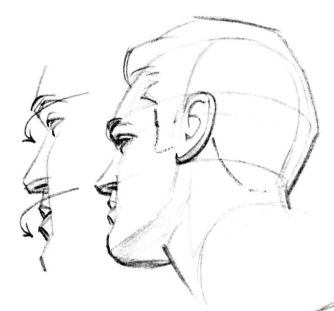

In this position the features go "around" the head and disappear.

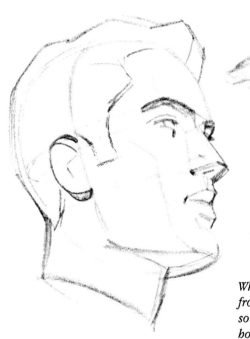

When the head is tilted back or viewed from below, emphasize the underplanes so that the angle is unmistakable. Notice how the nose hides one eye and most of the eye socket.

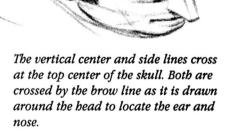

The vertical center and side lines cross at the top center of the skull. Both are crossed by the brow line as it is drawn around the head to locate the ear and nose.

The forehead hides the eyes and part of the nose, and the nose hides part of the mouth.

When the head is tilted back we see very little of the skull above the ear and eyebrow.

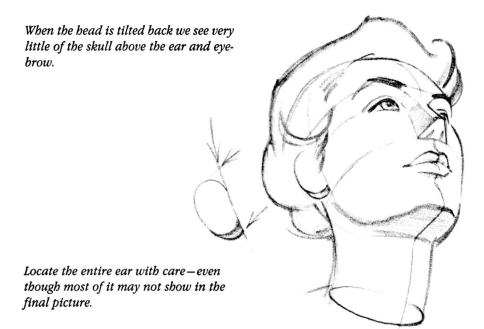

The tip of the nose hides most of the far eye in positions like this.

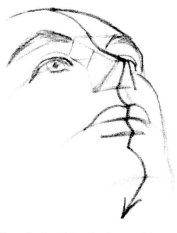

Locate the entire ear with care—even though most of it may not show in the final picture.

When the head is tilted, use this center line to relate the features to each other and the three-dimensional head.

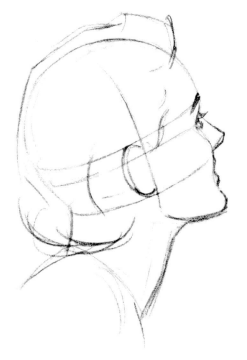

When the nose is blocked in accurately it helps establish the eye socket. Eyes and mouth curve around the head.

Compare these two views. Note how the features disappear in the one at right, where the head is turned away a bit more. Remember: In drawing, what you don't *see* is just as important as what you *do* see!

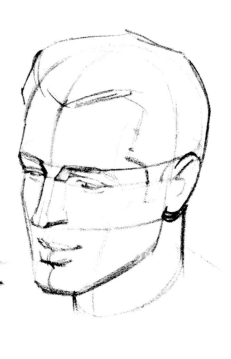

Planes of the Head

Early in the study of drawing, you should learn to mentally appreciate all the planes that surround the head, although, from any given point of view, only certain ones will be visible. This conscious understanding of the planes will help you present three essentials that make a good portrait drawing: (1) The action of the head, (2) its basic construction, and (3) the character and type of person you are drawing.

Six basic planes compose the head; five of these planes are visible. They are the top, the front, the back and the sides, with the last and sixth plane being hidden by the entrance of the throat and neck, leaving the under surface of the jaw the only portion of this plane intact.

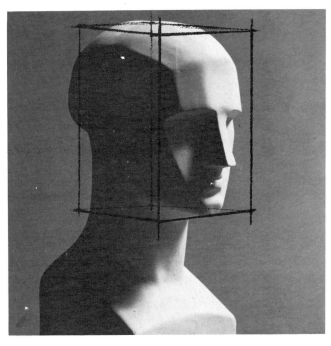

In its simplest form the head has six basic planes, like those of a box.

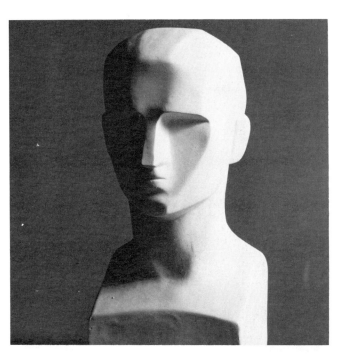

The basic planes are shaped by the contours of the skull and the features.

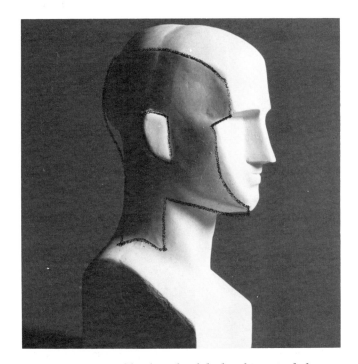

As seen in near-profile, the side of the head is a single large plane having small variations within it.

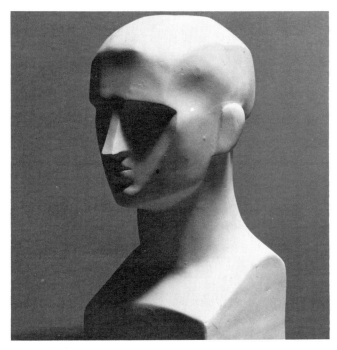

The artist should always keep these small facial details subordinate to the overall planes.

Basic Figure Drawing Techniques

Exercise in Planes

Following the proportions already established, draw a front view of a man's head from the photo below, basing the drawing on the planes of the head as indicated by the photo of the cast.

While the planes are simplified and may seem unnatural looking, they do provide a clear delineation of their basic shapes. When you look at a face you do not always see these planes, but they are there.

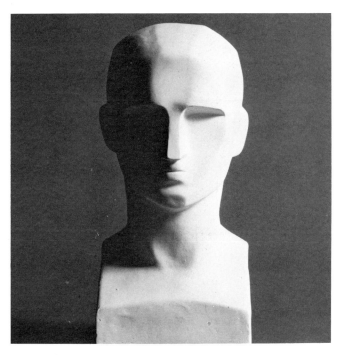

Compare this simplified cast with the photo of the model at right. Look for these basic planes in the photo.

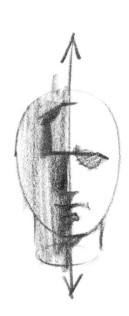

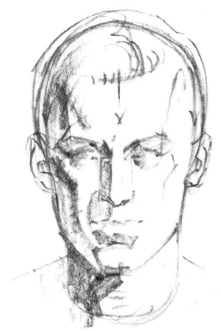

Here the basic planes have been established and refined so they match the features of the model.

In this drawing, the separation of planes was emphasized. Note how the feeling of solidity has been developed.

The Head

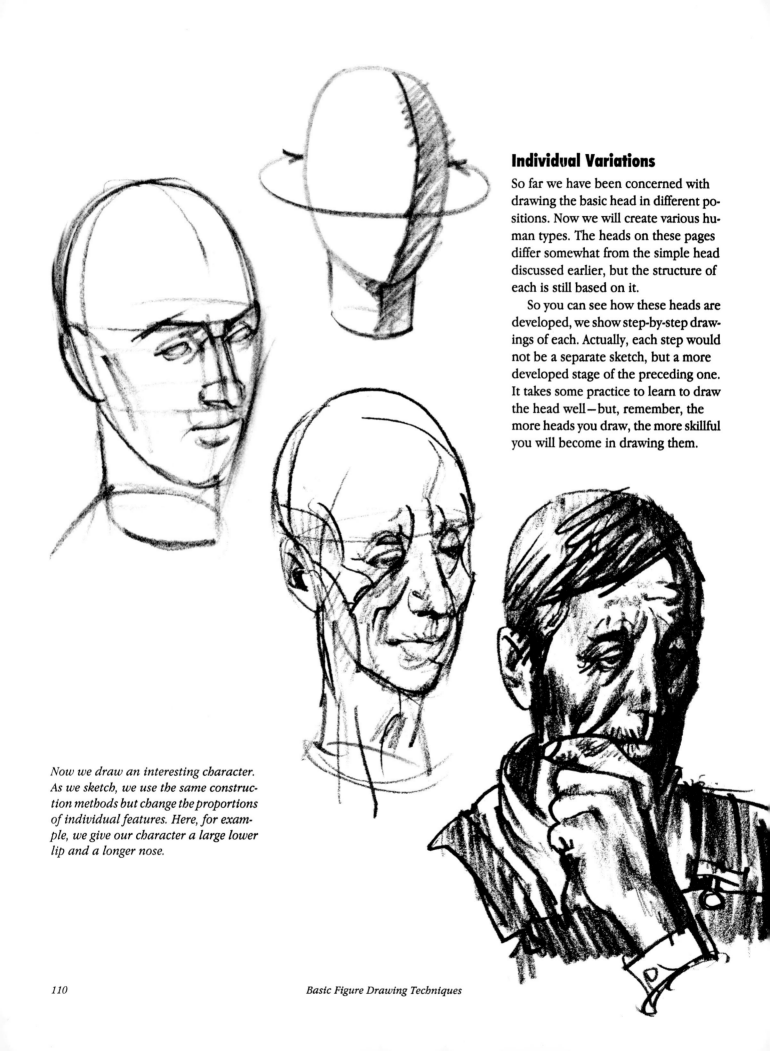

Individual Variations

So far we have been concerned with drawing the basic head in different positions. Now we will create various human types. The heads on these pages differ somewhat from the simple head discussed earlier, but the structure of each is still based on it.

So you can see how these heads are developed, we show step-by-step drawings of each. Actually, each step would not be a separate sketch, but a more developed stage of the preceding one. It takes some practice to learn to draw the head well—but, remember, the more heads you draw, the more skillful you will become in drawing them.

Now we draw an interesting character. As we sketch, we use the same construction methods but change the proportions of individual features. Here, for example, we give our character a large lower lip and a longer nose.

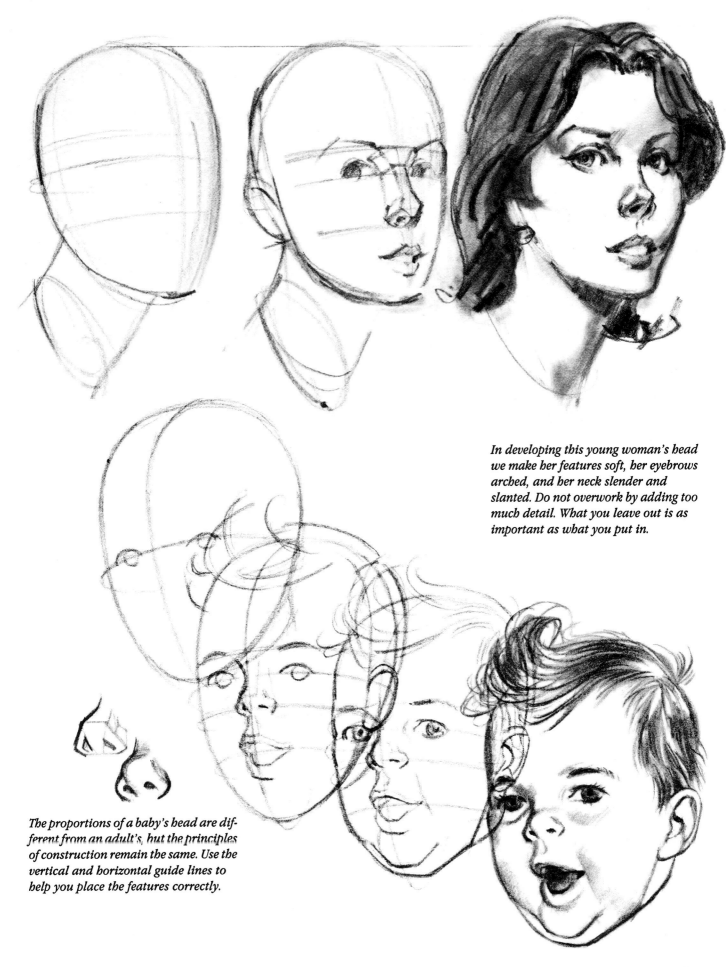

In developing this young woman's head we make her features soft, her eyebrows arched, and her neck slender and slanted. Do not overwork by adding too much detail. What you leave out is as important as what you put in.

The proportions of a baby's head are different from an adult's, but the principles of construction remain the same. Use the vertical and horizontal guide lines to help you place the features correctly.

Chapter Eight
HANDS

The hand is about the same length as the face from chin to hairline—a little more or less.

The hands, just like the face, should receive the careful attention of the artist. First, because aside from the face, they are the only generally exposed parts of the body. Second, and more important, because next to the face, they are the most expressive parts of the human body. They are capable of showing an amazing range of actions and emotions. Third, due to the many parts and because of the many masses and planes, the hands are quite difficult for the student to draw well without a great deal of study. It has often been said that the hand is the most difficult part of the figure to draw, and once you have mastered the drawing of the hands, you will greatly enhance the effectiveness of your figure drawing or painting.

A common mistake many students make when drawing hands as part of a complete human figure is to draw them too small. Let us repeat again, next in importance to the face come the hands. Make them large enough. If you hold your hand flat against your face, the tips of your fingers to the end of your hand where it joins the wrist should reach almost from the top of your forehead to the point of your chin.

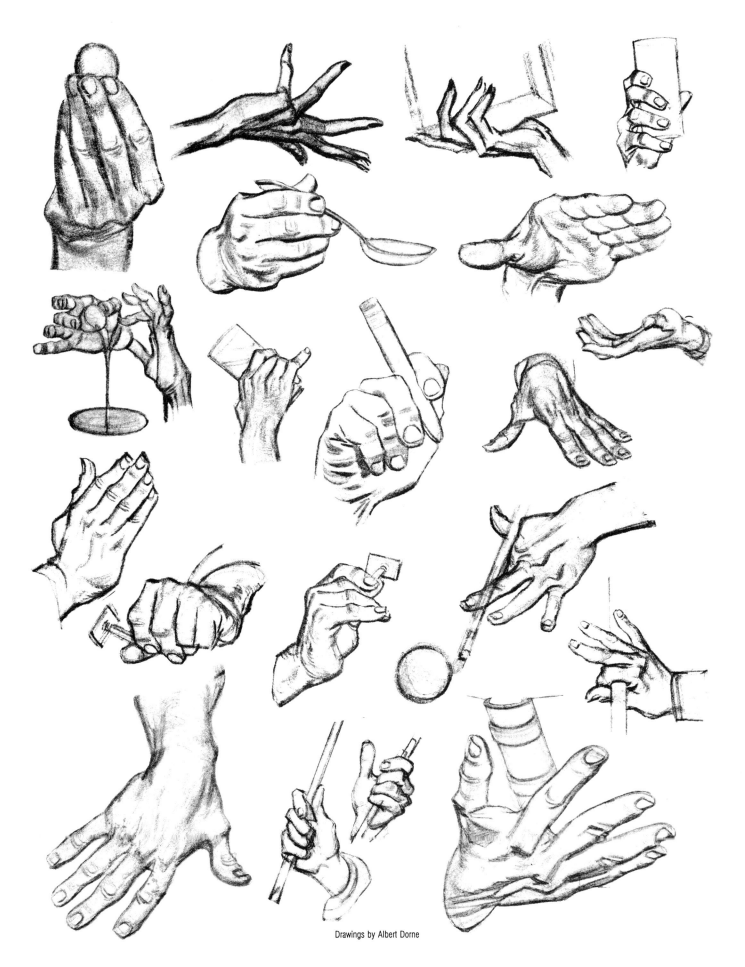

Drawings by Albert Dorne

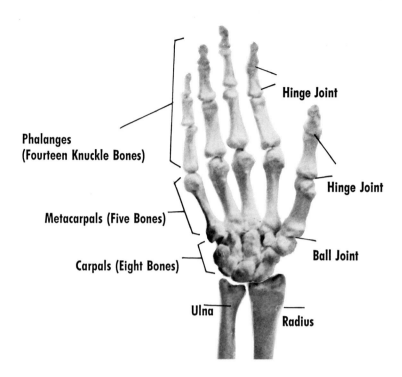

Phalanges
(Fourteen Knuckle Bones)

Hinge Joint

Hinge Joint

Metacarpals (Five Bones)

Ball Joint

Carpals (Eight Bones)

Ulna

Radius

The carpal bones make the wrist flexible.

When hand and arm are placed flat on a table, the wrist slants down to the hand. It does not touch the table.

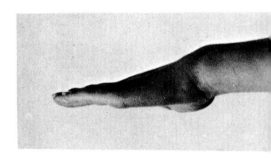

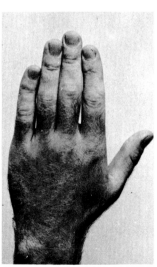

Forms of the Hand

The hand is composed of two masses—that of the thumb, and of the hand itself.

The double row of carpal bones of the wrist are mortised with those of the hand, making one unit. The hand always moves with the wrist. The wrist, twice as wide as it is thick, can also be called a universal joint for it is capable of side-to-side and up-and-down as well as rotary movement. It also enters into the large movements of the arm, giving grace and power as the action of the arm is transmitted to the hand by the wrist.

Lay your arm and hand flat on a table, palm down, and notice that your wrist does not touch the table top. You will see that the mass of the wrist rises from the hand at a slight angle where it joins the arm.

The thumb side of the hand is larger than the side of the little finger. The hand is broader at the fingers than at the wrist; however, at the wrist it is deeper. You will also notice on your

own hand that the palm is longer than the back of the hand.

The palm looks like a shallow bowl with square sides, and it is well cushioned on both sides near the wrist. A line across the wrist at a right angle marks the lower limit of the palm. The upper limit of the palm is also definitely marked by lines across the base of the fingers. Collectively, the fingers form a definite curve that rises highest at the base of the middle finger and then drops to cut the corner of the hand at the base of the little finger to join the curve running from this point to the wrist.

The thumb is set into the palm by the independent and highly mobile "ball" of the thumb, which gives a great range of movement, independent of the rest of the hand. With your hand held with its palm facing you directly, move your thumb in any direction. You can see it on almost every side.

The palm of the hand is thickly upholstered with a system of cushions and pads. On the front of the thumb

*The range of wrist
movement up and
down.*

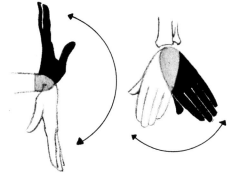

*The range of wrist
movement from
side to side.*

*Curved lines can be
drawn across the
fingertips, through
the joints.*

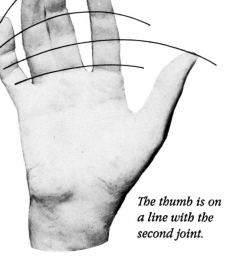

*The range of
thumb movement.*

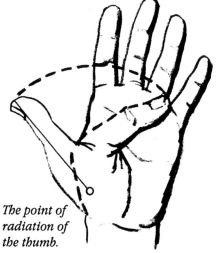

*The point of
radiation of
the thumb.*

*The thumb is on
a line with the
second joint.*

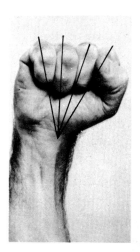

*When the hand is closed, the fingers also
point toward center.*

and fingers, as well as a considerable area of the palm, the substance built upon the bony foundation is literally padding.

The fingers all taper, individually and as a group, with the middle finger, being the longest, forming the apex. When the hand is open, the fingers have a tendency to converge towards the middle finger. In clenching the hand, notice that the fingers' ends point to a common center. The body of the thumb is heavier than the other fingers but, unlike them, only the last joint tapers.

The sections of the fingers are more square than they would seem at first glance, with the section containing the nail being almost triangular in shape, the nail with the flesh on either side forming its base.

To draw the hand correctly, you must have a knowledge of its internal structure—the bones that make up its framework and define its proportions. If you know the bone construction of the hand, you will never have trouble

drawing the hand with character and expression.

It is important to know the joints and their degree of limitation and movement. The first joint of the thumb and the first two joints of the fingers are hinge joints—that is, they move in one direction only, at right angles to the length of the fingers, folding toward the palm. They have no movement in a side direction at all. Fully extended, the topmost joint of each finger is bent very slightly backwards. The lower joints of the fingers and the joint of the thumb will bend forward to an acute angle, while the upper joints or fingertips cannot bend even to a right angle.

You need never be at a loss for models of hands to study. Even when you're drawing, you have another hand to study. The addition of a mirror in front of you to reflect your free hand will give you an infinite variety of poses to choose from.

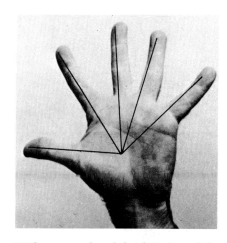

*With an open hand the direction of the
fingers converge to a line with the mid-
dle finger.*

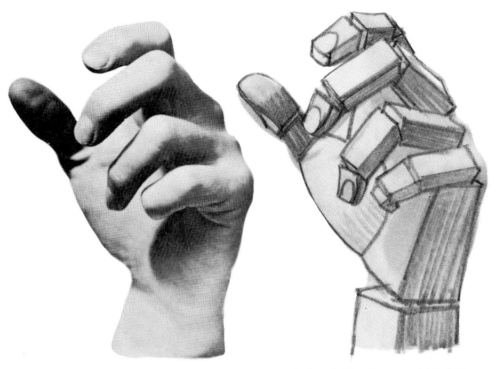

Blocking in the Hand

When we learned to draw the figure, we started with the basic forms, and we will again use simple forms to draw the hand. On this page there are photographs of two hands with blocklike forms diagrammed on their top, side and bottom planes. Study them carefully and, from now on, think of the hand and fingers this way as you sketch them in. As you gain experience you may omit these cube forms from your preliminary sketches, but you should continue to think of them as you work.

The other drawings on these pages show how you first establish the general size and action of the hand—then how to solve construction problems with the cube forms—and, finally, how to soften the edges and add realistic detail. As you work, think of the rhythmic flow of action through the wrist, palm and fingers, and of the solid structure that makes the hand look convincing. Try to show both in your drawing.

Man's hand: *The planes and blocklike shapes are easy to see on this man's hand. Notice that the finger joints work just like hinges and the hand "hinges" at the wrist.*

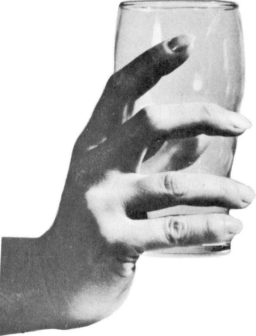

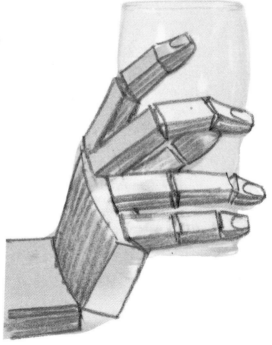

Woman's hand: *A woman's hand is more slender and graceful, but we can reduce it to the same blocklike structure.*

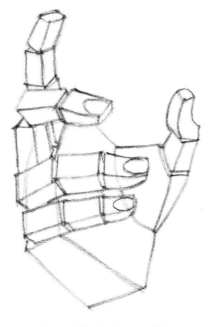

Foreshortening: *The block method of construction is useful in foreshortened views of the hand, because it is easier to imagine what happens in perspective to a cube than to a finger. Here we simplify the problem by establishing the position of the palm in relation to the thumb and then "build" the fingers on.*

Block in the palm, thumb and wrist first.

It is often helpful to divide the top edge of the palm into four sections where the fingers will attach.

Draw through block forms of fingers to establish the top, side and bottom planes in relation to the rest of the hand.

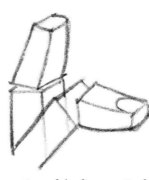

Hinge action of the fingers: *By drawing the bottom plane of the fingers carefully, you can be sure they bend at the proper angle. Note how each joint "hinges" on the next one—they do not rotate or twist.*

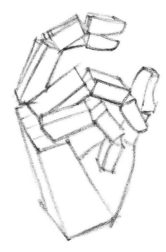

Complicated positions: *We can work out the position of the hands in any complex position, such as holding a ball, by drawing through and making sure the wrist, palm and thumb are properly related before drawing the details of the fingers.*

Important points in the action, proportion and movement of the hand, wrist and fingers.

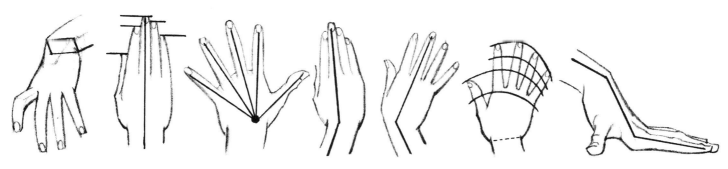

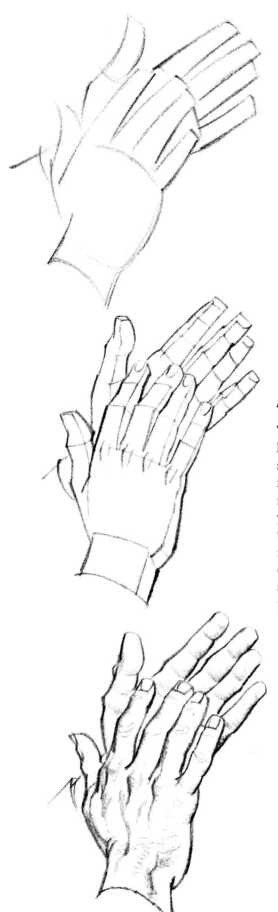

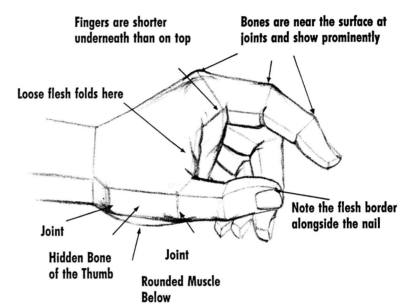

Fingers are shorter underneath than on top

Bones are near the surface at joints and show prominently

Loose flesh folds here

Note the flesh border alongside the nail

Joint

Hidden Bone of the Thumb

Joint

Rounded Muscle Below

"Humanizing" the Block Forms

The blocked forms of the hand will help you work out problems of pose and proportion. Converting the basic forms into more realistic contours is a matter of refining the shapes. Here, you'll need a helpful reminder of the underlying structure of bones and muscles. You will be particularly concerned with their effect on the outer surfaces of the hands as you interpret them from photos or posed models.

"Humanizing" the block forms: *Our purpose in drawing the hand is, of course, to make a convincing picture. The block forms serve merely to help us achieve this result. Here are some things to remember when translating these forms into a lifelike hand.*

Look for the overall gesture of the pose as a preliminary to drawing the hand. Notice here how the wrist, back of the hand and the pointing finger form a reciprocating curved shape.

Basic Figure Drawing Techniques

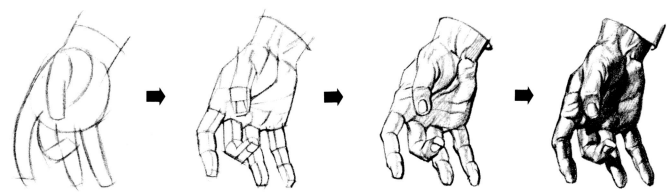

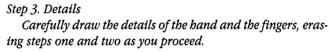

Step 1. Spacing and Placing
 Sketch in the action and the approximate area of the hand, fitting each part as it appears.

Step 2. Solidity of Construction
 The block method defines the planes and surfaces of the hand and fingers.

Step 3. Details
 Carefully draw the details of the hand and the fingers, erasing steps one and two as you proceed.

Step 4. Planes of Light and Shade
 Put in light and shade, taking care not to spoil the forms of the hand and fingers.

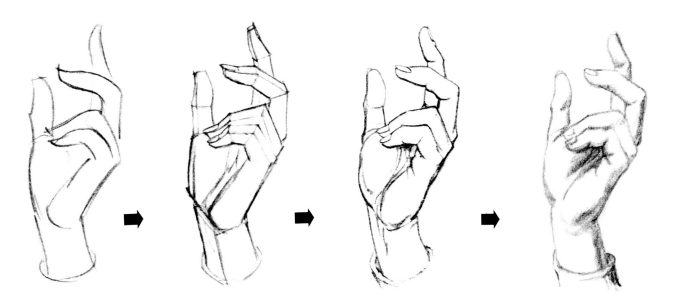

Once you achieve some proficiency, you'll find hands fascinating to draw. Study your own hands and draw them. With the aid of a mirror, you can pose them in almost any position.

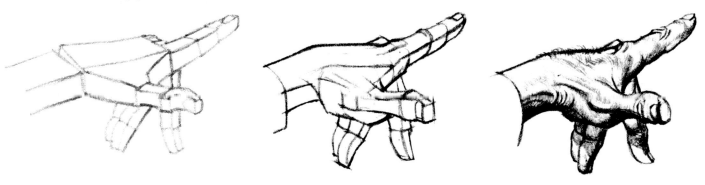

The Hand From Different Viewpoints

In the series of photos below the same pose of the hand has been held in each row, as the camera moved around it. You will note the striking changes that take place in the visible relationship of the fingers, thumb, and base of the hand, in just a small change of camera position, even when the eye level remains the same.

By drawing through you can locate the parts that are not visible, but that help you determine the proper locations of those that are.

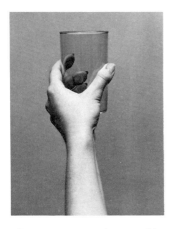

The transparent glass enables you to study the form and action of the palm and underside of the fingers.

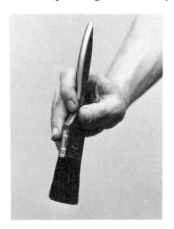

The hand and fingers adjust to the shape of the object they hold. Notice how the thumb works in opposition to the fingers.

 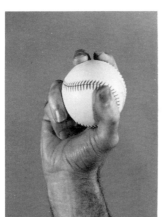 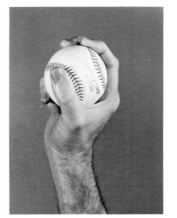 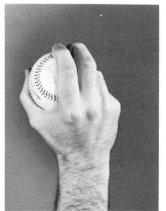

Not only the fingers, but also the body of the hand wrap around the solid, spherical form of the ball.

Basic Figure Drawing Techniques

Dos and Don'ts

One of the giveaways of an inexperienced artist is a weakness in the construction of the hands in an otherwise competent drawing or painting. Illustrated here are some of the common pitfalls, as well as their remedies.

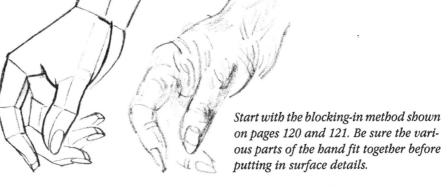

Start with the blocking-in method shown on pages 120 and 121. Be sure the various parts of the hand fit together before putting in surface details.

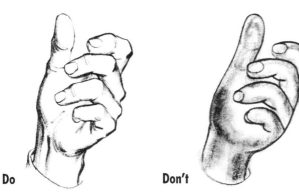

Do **Don't**

Keep in mind the bone and muscle structure beneath the surface. Don't round off all the forms of the hand or it will look rubbery.

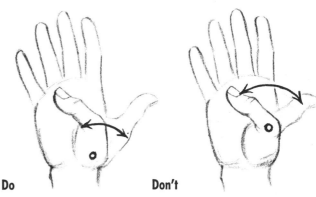

Do **Don't**

Remember that the thumb is attached at the wrist and swings independent of the rest of the hand. Don't limit the action of the thumb by swinging it only from the middle joint.

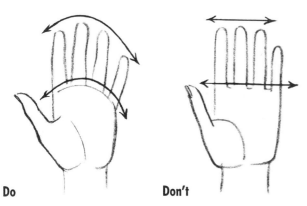

Do **Don't**

The fingertips form a curved line, and another curved line is formed where the fingers join the palm. Make sure these lines are not straight in your drawing.

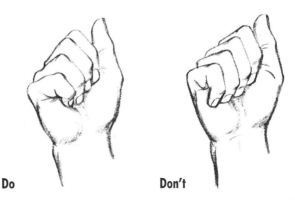

Do **Don't**

When the hand is closed, the fingers should point slightly toward the center of the palm. Don't fold the little finger straight down the side of the palm, or it will look stiff and unnatural.

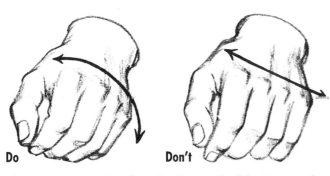

Do **Don't**

The wrist, fingers, thumb and palm are flexible. Don't make hands look stiff.

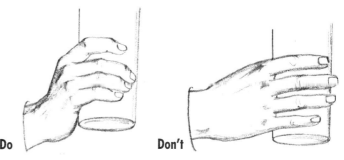

Do **Don't**

When the fingers are closed the back of the hand curves along the line of the knuckles. Don't flatten them out.

INDEX

METRIC CONVERSION CHART		
TO CONVERT	**TO**	**MULTIPLY BY**
Inches	Centimeters	2.54
Centimeters	Inches	0.4
Feet	Centimeters	30.5
Centimeters	Feet	0.03
Yards	Meters	0.9
Meters	Yards	1.1
Sq. Inches	Sq. Centimeters	6.45
Sq. Centimeters	Sq. Inches	0.16
Sq. Feet	Sq. Meters	0.09
Sq. Meters	Sq. Feet	10.8
Sq. Yards	Sq. Meters	0.8
Sq. Meters	Sq. Yards	1.2
Pounds	Kilograms	0.45
Kilograms	Pounds	2.2
Ounces	Grams	28.4
Grams	Ounces	0.04